HOW TO BEAT THE
TAXMAN
ALL YEAR ROUND

HOW TO BEAT THE
TAXMAN
ALL YEAR ROUND

BRIAN COSTELLO

Published in 1989 by
Stoddart Publishing Co. Limited
34 Lesmill Road
Toronto, Ontario
M3B 2T6

CANADIAN CATALOUGING IN PUBLICATION DATA

Costello, Brian
 How to beat the taxman all year round

ISBN 0-7737-5187-4

1. Tax planning - Canada - Popular works.
2. Income tax - Canada - Popular works.
I. Title.

Hj4661.C67 1989 343.7105'2 C88-094909-0

Cover Design: Falcom Communications and Design

Printed in Canada

Contents

Introduction *1*

1 You Must File a Tax Return: It Could Mean a Rebate *3*
2 File a Return on Time Even If You Don't Owe Tax *6*
3 Don't Wait until April to Claim Tax Deductions *8*
4 Being Late Can Cost You Money *10*
5 When It Comes to "Let's Make a Deal," Include Revenue Canada *11*
6 What To Do with Your Tax Rebate *12*
7 Make Sure New Year's Falls on the Right Day *15*
8 Start the New Year Off Right *16*
9 Don't Forget to Claim Any Extra Dependants that You Support *19*
10 You Don't Have to Be Married to Get Tax Exemptions *21*
11 Dependants and the Equivalent to Married Exemption *22*
12 Marry Your Child? *25*
13 Marriage Doesn't Always Pay *27*
14 Family Problems Can Cost and Be Taxing *28*
15 Always Let Lower-Income Spouse Keep Earnings *29*
16 When Inheriting Money, Put It in the Right Person's Name *30*
17 Transferring Deductions and Credits Can Save You Money *32*
18 Child Trusts Are Not Over After All *35*
19 Let Everything Grow in Your Child's Name *37*
20 Summer Camp Can Be Tax Deductible *38*
21 Charging Your Child Room and Board May Save Taxes *40*

22 Saving for Your Child's Education Can Save Taxes at the Same Time *42*

23 It Doesn't Always Pay for the Father to Claim Junior as a Dependant *44*

24 You and Your Child Can Benefit from Borrowed Money *45*

25 The Baby Bonus Is Really the Baby's *46*

26 Winning a Scholarship Not Only Helps with Schooling — It Saves Taxes *48*

27 Why Not Get Paid to Look for a Job? *50*

28 If You Work Outside Canada, You May Get a Tax Credit *51*

29 "Own" Your Boss and Save Taxes *52*

30 Having a Company Car Can Be a Taxing Ride *53*

31 A Benefit Is Not Necessarily Taxable *54*

32 If Your Boss Dresses You, It Might Be an Untaxing Experience *55*

33 Full-Time Workers May Still Be Classed as Students to Save Tax *57*

34 Delay Accepting Income Whenever Possible *59*

35 Don't Pay Tax on Nontaxable Income *61*

36 If You're Self-Employed, Don't Forget These Write-Offs *62*

37 Why Not Get Revenue Canada to Furnish Your Office? *64*

38 Pay Up Early and Save Taxes at the Same Time *66*

39 Does Buying a Year in Advance Save Taxes? *67*

40 Don't Forget the Past and Future When Claiming Losses *68*

41 You Can Hire a Family Member, but It's Easier to Employ a Friend *70*

42 How Would You Like a Tax-Deductible Vacation Every Year? *72*

43 Make a Night Out Tax Deductible *74*

44 Travel Free and Get a Tax Deduction *76*

45 Donate Antiques to Your Favorite Charity *77*

46 It Can Make a Difference When Claiming Charitable
 Contributions *79*
47 Get Paid to Volunteer *81*
48 Use Political Donations Properly *82*
49 Give Your Life Insurance Away *83*
50 Can't Afford a Home? This Way You Might Be Able
 To *85*
51 When You Own Mortgages or Annuities, Don't Pay
 Extra Tax *86*
52 Crisscrossing a Mortgage Can Save Taxes *88*
53 Renegotiating Your Loan *89*
54 Save on Taxes When Selling Your House *92*
55 When You Sell Your House, Try Not to Take a Vendor-
 Take-Back Loan *94*
56 Drop a Vendor-Take-Back Mortgage when the Rates
 Fall *95*
57 Buy a House for a Student *96*
58 A Retirement Home Can Be Tax Deductible *97*
59 We Can Make Our Mortgages Tax Deductible If We
 Want *98*
60 Another Way to Make Your Mortgage Tax
 Deductible *100*
61 Don't Mortgage Your Property Taxes *103*
62 When You Move, Do It Right *105*
63 Students Can Claim Tax-Deductible Moving
 Expenses *108*
64 Save Taxes by Picking the Right Month to Move *109*
65 When You Move, It Doesn't Always Pay to Sell *112*
66 Strategies For Your Fifties *114*
67 No Money? You Can Still Have an RRSP *117*
68 Your RRSP: What Should Be Inside? Outside? *120*
69 Why Settle for One RRSP When Two May Be
 Better? *123*
70 Don't Be Afraid to Spread Your RRSPs Around *125*
71 Shorten Three-Year Spousal Rule *128*
72 Get an Extra $3130 Tax Rebate on Your RRSP *130*

73 Letting the "Plan" Pay Can Save Taxes *132*

74 Benefits for the Young RRSP Holder *134*

75 Administration Fees Can Be "Made" Tax
Deductible *137*

76 Make RRSP Loans Tax Deductible *138*

77 RRIF Better Choice Than Annuity *139*

78 When You're Out of Work, Why Not Retire
Early? *141*

79 Life Insurance Can Even Pay Off While You're
Alive *143*

80 Pensioners Can Earn Loads of Tax-Free Income *144*

81 Saving Plans — Don't Forget Important Deductions *146*

82 Don't Use the Government as a Forced Savings
Plan *148*

83 Dividend Reinvestment Programs *150*

84 Make Sure You Borrow for the Right Purposes *153*

85 A Loan Can Unite the Family *154*

86 Borrowing to Invest in a Foreign Country *156*

87 If You Borrow Against a Life Insurance Policy, Try to
Make It Tax Deductible *157*

88 A Loan from Your Boss May Be Tax Free *159*

89 It Doesn't Pay to Cash Some Old Loans *161*

90 Pay Cash for Gold, Raw Land *162*

91 If You Pay to Learn, You May be Paid to Read *164*

92 Stock, Mutual Fund and Real Estate Commissions Aren't
Tax Deductible — Or Are They? *165*

93 Real Estate Income Isn't Always Taxable *166*

94 When Planning, It Pays to Look to the Outskirts *169*

95 If You Need Money But Don't Want to Sell Stocks, Try
This Idea *170*

96 Leverage Can Help Save Taxes and Create Wealth at the
Same Time *171*

97 Leveraging with Mutual Funds Can Be Easier than with
Real Estate *173*

98 Leverage Will Save Taxes but Don't Let It Cost You
Money *175*

99 Use the Three-Year Rule Properly *177*

100 If You Really Want to Earn Interest, Try This Tax-
 Saving Idea *179*

101 If You Don't Need the Regular Income, Don't Take
 It *180*

102 If You Really Want to Save Tax, Don't Earn Interest
 Income *181*

103 Swapping Dividends Can Save Taxes *183*

104 Tax Rates Are Marginal *184*

105 Limited Partnerships Limit Liability but Maximize Tax
 Savings *187*

106 Limited Partnerships Can Help Get Money out of an
 RRSP Tax Free *188*

107 How To Declare Capital Gains to Your Best
 Advantage *189*

108 Don't Forget to Claim Capital Losses *192*

109 When You Earn a Tax-Free Capital Gain, You Can Also
 Earn Other Income *195*

110 An Illness, as Sad as It May Be, May Save Taxes *197*

111 Win a Lottery? Take the Money Properly *200*

112 When Santa Has Financial Smarts *201*

113 What Does the Future Hold for Tax Rates? *204*

114 Looking Forward to Tax Savings *207*

115 Year-End Tax Tips *208*

Introduction

We've all seen changes from time to time, but, surely, the 20th century must be looked on as the time of most change — especially when it comes to tax planning. I mean, we've seen stock markets move to new record highs only to be massacred in October of 1987. We've seen investors make huge profits and suffer substantial losses. And then we've had the huge tax changes that seem to come almost monthly.

As if the tax system weren't confusing enough, the federal government and the provinces have introduced one tax change after another. They've made changes, rescinded them, and changed them once again. No wonder we find it confusing.

And now we have the first stage of tax reform with stage two on the way. The first stage offered lower tax rates and fewer brackets. However, they hardly simplified the chore of tax planning and filing our tax returns.

Stage two promises us even further rate reductions. However, lower tax rates don't by any stretch of the imagination suggest lower tax bills. The lost income-tax revenues will be recouped by increasing sales-tax revenues and governments' abilities to tax us in other ways.

As a result, it's up to us to learn as much about the tax system as we can. It's imperative that we take every tax deduction we can and defer taxes as long as possible and it's a must that we earn as many forms of tax-free income as we can. Here's the rationale: if there seems little doubt that tax rates are going to fall in coming years we should take every deduction we can get now when rates are still high. Even if we have to repay the taxes in coming years we will still be winners since we will repay them at lower rates than we save now. In addition, we can invest the tax savings and earn income that will give us even more money to pay our tax bills in the future. Naturally, we want to invest in safe, secure investments with good track records rather than risk-

ing our money by choosing investments that are more of a gamble than a sure thing.

I think *How To Beat the Taxman All Year Round* will be a very useful educational tool to help you understand the myriad tax changes, what you can do to protect yourself and how to use those changes to your advantage. As you read through the book you'll find there are many short chapters that each cover a specific topic. In addition, related topics have been grouped together in back-to-back chapters. The idea is to give you individual topics that you can study from time to time without requiring that you read the entire book in a sitting. If something whets your appetite you might go on, or you might take the time to seek out some professional help so you can implement some of the ideas that have been introduced to you.

Some of the ideas included in *How To Beat The Taxman All Year Round* involve the use of products like stocks, mutual funds, real estate and tax shelters. When you meet with a financial planner who sells these types of products you might suspect that he or she is biased, that he or she has an axe to grind because they earn a commission selling these products. Well, I don't sell products — in fact, I no longer take clients. I earn my living by writing books, articles, TV and radio shows and public speaking. As a result, I feel my research has made it possible for ordinary taxpayers to take these ideas to a financial consultant and know that the ideas can be implemented without worrying that they will be sold only product with no tax planning.

1

You Must File a Tax Return: It Could Mean a Rebate

Even though you have no taxable income you may still find it worth your while to file a tax return. You may be able to claim tax losses that can be used to recoup taxes already paid in past years and you may be able to claim a refund for taxes already paid this year. It's the only way you can claim federal and provincial tax credits owing to you, and you must file a tax return and claim capital gains earned in 1988 — even though they are tax free until you exceed $100,000.

Many taxpayers who run a small business on the side while working full time elsewhere make the mistake of comparing their income and expenses in the wrong manner. If their income exceeds their expenses they claim it as taxable income. If their expenses are greater than their income they claim "zero." Instead, they should claim negative income equal to their losses. That will lower the taxes they were supposed to pay on their full-time income.

This same theory applies to self-employed individuals who have not earned enough to be taxable. It's important that they claim these expenses as they can be carried back to previous years' tax returns, which could result in a tax rebate of taxes already paid. Or these deductions can be carried ahead and used as tax deductions against income earned in coming years.

Rental income also falls into this category. If you have negative rental income it should be claimed on your tax return as it will save you taxes otherwise owing on other forms of income.

To receive the remainder of the child tax credit and qualify for the automatic advance payment next fall, the mother (father if he is a single parent) must file a tax return. Last November,

3

an advance payment of $300 was automatically sent to those Revenue Canada felt qualified. To get the remainder, it is a must to file a return. Don't forget, also, that if you had a newborn in the last few days of the year you qualify for the child tax credit for that child for the entire year plus the full dependant exemption and one month's family allowance cheque. Everybody thinks that the first child of the new year gets lots of gifts, but children born right at the end of the year are worth cold, hard cash. One other thing to remember: even though the child born right at the end of the year didn't need child-care expenses, the family still qualifies for another $2,000 — provided, of course, that you paid child-care fees. If it cost $3,000 to care for one child you could only get tax relief for $2,000. With a second child you now qualify for $4,000 in tax relief, even though no money was expended on the second child.

It's also a must to file if you want to claim the federal sales tax credit. Every person who is 18 or over, is married or is the parent of a child, should look at Schedule 9 to see if they qualify. Those age 18 and over must file a tax return to get it. Those under 18 will be claimed on their parents' tax returns. There is, however, a requirement that family income not exceed $15,000. Above that it is gradually reduced.

The interesting point is that a parent can claim a child over the age of 18 as a dependant exemption if they are attending school full time. The parent cannot claim the child as a $25 federal sales tax credit (FST), but the dependant can *and should* file his or her own tax return to claim a $50 FST. The fact that he or she is 18 means they can claim their own FST. In fact, many families miss this credit in cases like this. They may not be able to claim their child as a dependant because he or she earned too much, and they may not bother with the FST section as their family income is well above the $15,000 level. In addition, the child may not be taxable because he or she didn't earn enough income. Yet, it's important that tax returns be filed to claim the FST in the dependant's name.

Another example involves individuals who married before turn-

ing 18. These taxpayers qualify for the full $50 FST, provided his or her spouse agrees not to claim this credit.

It's doubly important that taxpayers get accustomed to claiming tax credits that are rightfully theirs. As we work our way toward next year's tax return, when tax reform will introduce many more tax credits, you'll want to become more aware of how they work. Tax deductions lower our income for tax purposes. Tax credits wipe out taxes owing — and in many cases rebate to us taxes that we have already paid. The refundable tax credits give us money whether we owe taxes or not. The day is coming when it will only be tax credits. Get accustomed to it now.

2

File a Return on Time Even If You Don't Owe Tax

Many Canadians don't bother to file a tax return on time because they expect a tax rebate. They think penalties only accrue when they owe money and don't file on time.

Unfortunately, that's not quite true. You see, when the April 30 deadline rolls around, Revenue Canada instantly charges interest on overdue accounts but doesn't bother to pay interest on the money it owes us, unless the tax return has actually been filed.

Many taxpayers feel that they're earning interest on any rebates they qualify for even though they haven't filed their tax return, but such isn't the case. Revenue Canada's policy is that they'll start paying interest the day the return is filed or May 1, whichever comes later. That, in itself, is the perfect reason to get your tax return in early in the year when you know you have a rebate coming. Ottawa has already had your money for most of the year without paying interest on it, and they have no intention of starting to pay interest until May 1. Knowing that, it's advantageous to file as soon as you can. The sooner you get your rebate the sooner you'll be able to start earning interest on your money, or put it toward bills and credit card balances or your mortgage.

In fact, it's sad to say but many Canadians are caught in the trap of thinking that they have to pay their taxes automatically as requested by Revenue Canada and that they cannot get a tax rebate before April 30. Such is not the case. If you manufacture a tax deduction partway through the year that entitles you to a tax rebate or a reduction in your tax bill you can ask for an immediate tax change.

The other consideration that's important in this discussion is something called the three-year rule. It states that we can only

go back three years when we want to reopen tax returns. If you haven't filed a return for four years you have no hope of reopening that file and capturing any money owed from that four-years previous return. As a result, the tax rebate and the interest you may think you have coming is lost. There's no way you can get it. It's lost money. All the more reason, then, why you should file on time. You get back money that is yours and can use it to your best advantage. If you delay, you stand to lose it.

3

Don't Wait until April to Claim Tax Deductions

Most Canadians make a serious mistake on their tax returns. They wait until they file their T1s each year to claim tax deductions. You don't have to wait — and if you didn't you might be able to arrange for less money to be withheld from your paycheque each week.

At the start of each year, we tell our employers how many tax deductions we're going to qualify for. Are we married? Do we have any children? Are there any other tax deductions that will lower our withholding taxes?

Most of us stop after claiming the spouse and children. But should we? There are other deductions and exemptions that can be claimed at this time.

What if you pay alimony or maintenance payments to an ex-family? If the result of a legally written agreement or court order, those expenses can also be claimed as tax deductions at this time. In addition, it's not unusual for Revenue Canada to accept business losses from previous years when computing this calculation. Also, if you can prove that you've already contributed to your registered retirement savings plan or to other similar tax shelters, you may be able to convince your employer — or petition Revenue Canada to order him or her — to reduce your withholding taxes.

The same goes for interest paid on investment loans. Have your financial planner or stockbroker arrange for it early in the year rather than waiting until the new year when you file your tax return. That way you'll have more money coming in each month rather than having your employer automatically remove it from your paycheque each week and send it off to Ottawa.

Just in case you think it's not important, consider these numbers. Let's say you pay $10,000 a year in maintenance. In the average 35% tax bracket you'd qualify for a $3,500 tax rebate at the end of the year. That's just about $300 per month that's being deducted from your tax return even though it needn't be. Imagine what you could do with an extra $300 per month. You could either increase your standard of living or go on a nice vacation — or use the money to pay down your mortgage. Three hundred dollars per month in extra income surely would do a lot of damage against your mortgage balance.

And don't forget that this is tax-free income. It's not salary or investment income, it's a tax rebate. As a result, it's more like getting a $500 per month salary increase.

As mentioned earlier, it needn't be alimony or maintenance. It could be interest you've committed to pay on an investment or business loan, or monies contributed to a registered retirement savings plan. And this calculation doesn't have to take place right at the start of the year. It can be made at any time during the year. All you have to do is approach your employer or show Revenue Canada that you need the money and they'll authorize your employer to make the changes.

Now that interest is no longer tax free it pays to contribute your maximum RRSP contribution at the beginning of the year. Rather than waiting until the end of the year, though, you should also appeal to your employer and Revenue Canada to have your withholding taxes reduced since you can prove you have this tax deduction.

The same theory applies to purchasing tax shelters at the start of the year rather than waiting until the final deadline. New legislation demands that tax shelters amortize their initial expenses over five years rather than lumping them into the first year or two. As a result, it's better to buy a tax shelter at the beginning of the year rather than waiting until the final deadline. Again, when you do, it's advantageous for you or your financial planner to approach your employer or Revenue Canada about accelerated use of your deductions to reduce your income-tax withholdings at source.

4

Being Late Can Cost You Money

We all know that our tax returns have to be filed by midnight, April 30th. If we don't meet that deadline, we're going to have to pay some extra dough to the taxman.

How much? Well, it all depends on how late you are. The sooner you get the return filed, the sooner you start to save money.

The first step should be to file on time even if your return is incomplete. If you don't get it in by midnight, April 30, you instantly face a penalty of 5% of the amount that you already owe. That's an automatic.

Then there's a second penalty equal to 1% per month to a maximum of twelve months.

And on top of that, you'll also be nicked with an interest bill starting May 1 until you pay up. The interest rate is changed from time to time as interest rates fluctuate, but at no time does it qualify as a tax-deductible expense.

Revenue Canada considers business and investment loans as tax deductible. But this loan is not. As a result, the interest you pay when you file late will burn a bigger hole in your pocket.

Even if you don't have all the information and even if you don't have the money, it's still best to file your return on time so that you can avoid all the penalties and interest that will accrue if you miss the deadline.

If you don't have the cash, Revenue Canada will bill you. And, yes, interest will be added. But at least you'll save all the penalties.

5

When It Comes to "Let's Make a Deal," Include Revenue Canada

Most of us are intimidated by the taxman, and justifiably so. We file a tax return that we feel is legitimate only to find out that it's not acceptable. But don't worry. Revenue Canada officials are always open to discussion, especially when there's a legitimate beef involved.

If you receive a request for more information, always reply quickly. The individual who looked at your return has the right to ask for clarifications. If you can't provide the information requested — or don't within a reasonable period of time — your tax deductions will be refused and you'll pay full tax.

If you don't have the right information, send in what you have. The assessor will look at it and decide whether or not to ask for more. If it's decided that your information is acceptable, you're off the hook. If you need more, you'll hear back.

In some cases, you may not be able to get the documents you need. The company may have closed its doors, you may be on bad terms with your previous employer, or you may not be able to find the documents you need.

If you simply ignore the tax department's requests, you leave yourself open to problems. They don't have the answers, so they can't be expected to make a decision.

When you get a request, give the tax assessor whatever information you can find. It shows that you are as interested in arriving at a settlement as the assessor is. As a result, you'll save taxes and penalties.

6

What To Do with Your Tax Rebate

So, you're one of the millions of lucky Canadians who've won the country's biggest lottery — you get a nice fat tax-rebate cheque. But now you're wondering what to do with it. Should you go out and have a good time, should you buy something, just what should you do? Well, I have some ideas that may increase the value of this windfall.

First of all, we should try our best not to get a tax rebate. Let's face facts. This isn't a gift. It's a return of our own money that was mistakenly withheld from our paycheques for Revenue Canada's use. All the time they've had our money they haven't had to pay one cent of interest. They've had an interest-free loan and are only now returning our own money back to us.

If you receive a nice fat tax-rebate cheque every year you should take a few minutes to reassess your situation right about now. Either ask your employer to reduce your withholding taxes, or if you need a forced savings plan, have an amount equal to the reduced withholding taxes subtracted from your paycheque. Use it to buy Canada Savings Bonds on payroll deduction, mutual funds on automatic monthly payment plans or anything else that would produce a chunk of money each spring that had also been earning interest as it was accumulating.

But that's for next year. What do we do if we have a $700 tax-rebate cheque (or thereabouts) coming this year? What's our best choice when it comes to spending it?

My first choice is to try to multiply its value. The easiest way is to immediately (before I'm tempted to do something else with it) contribute it to my RRSP. I mean, if this is found money why not use it to produce even more money?

You'll have to assess your situation to determine whether there

is room in your tax situation for a contribution to an RRSP. If there isn't — for example, if you contribute fully to a company pension plan — you'll have to look elsewhere for tax relief. If, however, you can make a contribution to your RRSP you will be a double winner. You manufacture an instant tax deduction and you save taxes on any investment income you earn.

If you contribute your tax-rebate cheque to your RRSP you can ask your employer to treat this contribution as an immediate tax deduction. He or she can be empowered to reduce the amount of money deducted from your paycheque and remitted to the tax department because you can prove you have an extra tax deduction. That will increase your take-home pay and give you more disposable income throughout the year. The second way you win when you contribute now is to save taxes on investment income. This year, for the first time, we can no longer earn $1,000 in tax-free investment income. In this case though, all the investment income will be earned inside your RRSP where it's tax free.

If you don't want to, or cannot, contribute to your RRSP you have a variety of other choices. You could blow it on a new outfit, a vacation, something for the house, or depending on the size of the rebate (naturally), a night out on the town. And, you know, from time to time everybody should do these things. But, if you really want to get some mileage out of your tax-rebate cheque you can do better.

How about using it to pay down your credit card balance? Some credit cards charge you as much as 28% interest when you consider compounded interest. Most charge you interest immediately when you buy new items while you have an outstanding balance. If you used your rebate to pay your credit card balance down to zero you would now be free to buy more goods without incurring any interest expenses until your new billing date. In fact, if you had a $750 balance and used your rebate to buy an equal amount of goods you'd pay more interest than if you paid off your credit card bill and immediately purchased the same item using your credit card.

A natural move, where possible, would be to use your tax

rebate to pay down your mortgage. In most cases personal mortgages are not tax deductible. As a result, they cost us much more out of our pockets in after-tax dollars than we realize. I say "where possible" because not every mortgage allows extra payments, and many others won't necessarily allow payments right when your rebate cheque arrives in the mail.

If possible though, using your tax-rebate cheque to pay down your mortgage is an ideal choice. The money goes directly against your principal so you immediately reduce the size of your loan. In addition, it eliminates the need to pay interest on that portion of the principal for the rest of the life of the mortgage. With one extra payment you can shave a year or more off the end of your mortgage.

For some, of course, receiving their tax-rebate cheque is an opportunity to go to the track, to buy some lottery tickets, or to have a party. For most, though, it should be looked on as an opportunity to create more tax relief and substantial savings.

7

Make Sure New Year's Falls on the Right Day

For individuals who work for an employer, they've no choice. Your year end comes at midnight, December 31, each year. For self-employed and businesspeople, though, it's a different story. They can pick and choose their year end — and save some taxes at the same time.

If you work for a company, you have to sort out all your financial affairs by the end of the year with the exception of one tax shelter, the registered retirement savings plan. As a businessperson, though, you can pick any day you want. For example, you could choose January 31 rather than December 31. When you do this, all of the income earned won't have to be claimed on your tax return until the end of the year in which you received it.

Having a company year running from January to the end of December means you pay tax in the spring when you file your tax return. Running from February until the end of January means the income wasn't earned by you until the end of next December and you don't have to claim it until the following spring.

Picking the right year end, then, can save you having to pay your tax bill for at least one full year.

Many individuals think this applies only to incorporated companies. However, such just isn't the case. In fact, it's often most useful to somebody who works full time at a company who also has a small unincorporated company operating on the side. The salary will be fully taxable while deferring tax on the unincorporated profits will give you working capital to help your company grow.

8

Start the New Year Off Right

So, here we are, in a brand-new year — but this one promises to be more confusing than usual. We know the Conservatives now have a mandate to continue with tax reform and we know they're going ahead with free trade. At the same time we have confusion over the new registered retirement savings plan rules and the direction of interest rates. As a result, it's more important than normal that we get the year started on the right foot.

The first thing to do is look at your investment income situation. Remember, this is the start of the second year of tax reform. Last year was the first year of the elimination of the $1,000 tax-free interest deduction. Yet, because we haven't filed our tax returns, few taxpayers realize the impact of the loss of this deduction. It's going to hurt those who continue to opt for interest income. You'd be better off taxwise if you restructured your investments right now when the year is young so as to minimize the amount of interest you earn. You could switch to blue chip stocks that don't react with much volatility but that pay a good dividend and have for many years. Canadian dividends qualify for the dividend tax credit which minimizes or can even wipe out the tax payable on these dividends. In addition you could lock your money into interest-bearing investments that will compound for at least three years. That way you won't have to pay any tax until three years down the road. However, at that time you will pay three years' worth all at once. The advantage is that you've been able to compound your share and the taxman's for three years rather than one.

Another consideration would be to buy some investments that pay a very low taxable yield right now but, based on past per-

formance, can normally be expected to also produce a nice fat tax-free capital gain sometime in the future.

The easiest way to address this problem — and probably the easiest and least risky — is to contribute to your registered retirement savings plan right away for this year and last year. Most of us wait until the final deadline at the end of February to contribute for last year. But if you have the money in the bank earning taxable interest you're better off contributing now. The money will earn at least as much inside the plan as outside but it will compound tax free for as long as you leave it in there. The next step of course would be to contribute this year's maximum as well. Now you have two years' worth of contributions earning tax-free income rather than taxable income.

There's a very big change this year that will have a major impact on investors and the investment community. Tax shelters used to lump all kinds of tax relief into a year or two right at the start of the project. Now many of the tax deductions offered by tax shelters have to be amortized over five years. As a result, it is actually better to buy your tax shelters now, at the start of the year, rather than waiting until the last minute in December. In addition, the money you pay toward the tax shelter will no longer produce taxable interest in your bank account.

It is imperative that we look at investing in ourselves in 1989. That means pay off as many non-tax-deductible debts as possible. The natural start is our credit card balances. No matter how you look at them, they are a loan from the credit card company. In addition, they are, in most cases, the highest-cost loan we will incur. Credit card loans can cost as much as 28% interest when the compounding rate is considered. For those in the maximum tax bracket, that means the real out-of-pocket cost is more than 50% a year. That's a pretty good incentive to pay off these loans, wouldn't you say? All you have to do is to approach the card issuer and request a personal loan at 12% or so to pay off one that can cost as much as 28% annually before tax. Naturally, it would be even better to use existing cash balances to pay down these outstanding bills before you borrow.

The next step is to pay off other debts, including mortgages and personal loans. Non-tax-deductible debts should come first. Those bearing the highest interest are most important and those with the longest term of compounding should also be considered.

Probably one of the biggest mistakes made by taxpayers is to authorize their employer to withhold too much tax from their paycheques. Too many taxpayers claim they are single rather than married with a family. That way there is more tax withheld at source than necessary. Come tax rebate time, they get a nice, fat rebate cheque. But this is a mistake. If you really need a forced savings plan have the money withheld from your paycheque and paid into your RRSP or against your mortgage or other loans. That way you will save interest and also have a forced savings plan.

Other taxpayers have too much tax withheld because they don't claim tax deductions to which they are entitled. If you contribute to your RRSP or a tax shelter early in the year you have the right to petition Revenue Canada and have your withholding taxes reduced. After all, you are entitled to this tax relief. Why should you have to pay taxes on the amounts involved? In addition, if you pay maintenance or support to an estranged spouse and can prove it you also have the right to have your employer reduce the taxes withheld from your paycheque. For those who pay quarterly you can reduce your quarterly instalments by a similar amount.

Many Canadians chose not to cash in their Series 36 Canada Savings Bonds last fall because they didn't want to pay tax on years of compounded interest. But, now that we're into 1989, you should cash these bonds immediately and put the money to use elsewhere. The interest will be taxable in 1989 but you won't have to actually pay the tax until the spring of 1990.

One other strategy that will save taxes at this time of year is to contribute to a registered education savings plan (RESP). There's no tax deduction for your contribution but all the money will compound inside the plan for as long as 21 years.

9

Don't Forget to Claim Any Extra Dependants that You Support

Under tax reform we no longer claim dependants as a tax deduction. Now they are a tax credit. That doesn't mean they are less valuable though, since in some cases their value has been increased. The theory behind using tax credits is that everybody gets the same tax advantage. That means an increase in value for lower-income people and a decrease for those in the higher brackets. It also means that those in the mid to lower brackets should pay more attention to their relatives living here in Canada and outside our borders.

As long as an individual is related by blood, marriage or adoption, and lives with you, you may be able to claim him or her as a dependant exemption. Included are parents, children, grandparents, grandchildren, aunts, uncles, nieces, nephews, great-grandchildren, and illegitimate children.

Through marriage, husbands and wives, all in-laws, including brothers, sisters, grandchildren, aunts and uncles, grandchildren, nieces, nephews, great-grandchildren, and illegitimate children of a spouse can be claimed.

Those who can be claimed because of adoption include children, fathers or mothers, and brothers or sisters.

Remember, though, that there are also income restrictions. When filing your tax return, you should always check Schedule 6 if you have any dependants other than a spouse and children.

In addition, children, grandchildren and spouses who live outside Canada may be claimable.

And don't forget that single or separated taxpayers can use the equivalent to married exemption which can save substantial tax dollars. There are also changes in the equivalent to married

exemption so make sure you check Tip 48 to see how it can help you.

10

You Don't Have to Be Married to Get Tax Exemptions

Parents know they get special tax exemptions for their offspring that can ease some of their tax burden. I use children in this example since a spouse is no longer an automatic deduction now that so many families have two working spouses.

And a spouse isn't even necessary when it comes to claiming dependant exemptions since single parents can just as easily claim dependants as can a couple. In fact, single parents can have it easier than the conventional family.

The first consideration is the equivalent to married exemption. It's covered in Tip 12. After that, though, there are other savings.

When two spouses are involved, the lower-income spouse must claim the child-care expenses. However, there are many cases where that spouse doesn't earn enough to be taxable. As a result, the child-care deduction is useless to families in that position.

With a single parent, though, there's less problem. In that case the parent involved has to use only his or her own income in arriving at child-care deductions. The same also applies to the refundable child tax credit. When two incomes are involved they must be combined to determine any restrictions. However, when there's only a single parent involved, it's more difficult to exceed the threshold level. As a result, the child tax credit can be larger for a single parent than for a married couple.

Single parents should also remember that day-care expenses can include summer camp, hockey school, etc. As a result, some of the expenses incurred in the summer months when the children are out of school can also be considered tax deductible (see Tip 20).

11

Dependants and the Equivalent to Married Exemption

While Revenue Canada has not yet moved to the joint tax returns that are popular in the United States, they have become more liberal in the way they recognize marriage and dependants. Some of the changes are beneficial for taxpayers, some very painful.

At the same time, they have continued to recognize that just because a taxpayer isn't married doesn't mean they don't have dependants.

Even though many Canadians now live together without getting married, Revenue Canada continues to deny the spousal exemption to anybody who is not married. While that may create a hardship for some taxpayers, it can also be a bonus for others. If both spouses work in a marriage, neither can claim a dependant exemption when they both exceed $4,220. However, in a common-law relationship where both taxpayers work, one spouse is still able to claim the equivalent to married exemption if he or she supports a dependant who qualifies. Effectively, in this case it pays not to be married. And, that's not to suggest that nobody should marry. No, it means that all married couples should lobby for better treatment.

Consider this scenario. In a married family of three, where both spouses work full time, the father (normally) will be able to claim a $560 tax deduction for a child under the age of 18. However, in a common-law situation where both spouses work, one parent would be able to claim an equivalent to married exemption of $3,700 provided the child lived at home and was supported by the parent claiming the exemption. The couple claiming the $560 exemption would save $196 in taxes if they were in the 35% tax bracket. The common-law couple would save $1,295 —

a difference of $735 — simply because they weren't married. Actually, the equivalent to married (ETM) exemption isn't limited to this use. It is regularly missed by thousands of single taxpayers who never even think they qualify for a marriage-type exemption.

Any taxpayer who is single, separated or divorced should automatically look at Schedule 6: Additional Personal Exemptions. It says that anybody who is not married can claim a $3,700 tax exemption for a dependant that they support who lives with them or in a dwelling maintained by them. That means that divorced or separated parents can claim a $3,700 exemption for a child they support rather than claiming the usual child exemption, which is worth $560 for a child under 18 and $1,200 for a child 18 to 21 or older if attending school full time.

But, it isn't limited to children. Take a single taxpayer who supports a parent or any other relative. That taxpayer could claim a $3,700 tax exemption for that parent as if they were married.

There are income restrictions though, as there are for all dependant exemptions. The spousal exemption is diminished once his or her net income exceeds $520. Children are allowed to earn more ($3,100 for dependants under 18, $1,820 for those 18 and older) before being lost as exemptions so it may still be advantageous to claim a child as a child. However, when their income is very low it's very much worth your while to try and claim the ETM rather than the child exemption. The ability to earn only a small net income before being eliminated also makes it beneficial to claim the youngest child as the ETM when more than one child is involved. The older a child gets the more likelihood that he or she will get a part-time job or earn some form of income. In addition, once a child reaches age 18 he or she qualifies as a larger tax exemption. All the more reason to claim a younger child as the ETM, as you get two large exemptions.

It's easy to say that parents and other relatives can also be claimed in this fashion. However, the income restrictions can eliminate this practice in many cases. A parent's net income will include pension (including CPP and QPP), Old Age Security payments, unemployment insurance, workers' compensation pay-

ments, social assistance payments and supplements received from federal or provincial coffers, plus investment income and any other income received. However, there are relatives who will qualify and it's a shame that many single, separated or divorced taxpayers don't utilize this tax relief.

Speaking of relatives, many taxpayers send money overseas to relatives. Those payments can indeed be tax deductible, provided the relative meets the normal income requirements. Again, check Schedule 6.

Finally, don't forget that a dependant 18 or over who is mentally or physically infirm can be claimed as a $2,700 tax exemption.

12

Marry Your Child?

While it sounds incestuous to suggest that somebody marry a child, especially for tax purposes, it is valuable to try to accomplish the tax savings that would result. And, no, you don't really marry your child.

With a two-parent family one spouse often gets to claim the other spouse as a tax exemption. Depending on the year, it's worth more than $5,000 in tax relief. For the average Canadian in the 35% tax bracket that means a tax rebate between $1,200 and $1,300.

With single-parent families, though, this spousal exemption doesn't exist. There's no spouse so there's no need for an exemption. However, when there's a child involved there is something called the equivalent to married exemption. It allows a single parent to claim a child as if he or she were a spouse. There's no marriage involved — just a tax deduction that normally goes with being married.

Normally a child under the age of 18 is a $65 tax credit against our federal taxes. If you add on the provincial portion it translates into something like $95 for the average family. After the first two children the numbers jump up to $130 federal and $190 combined. But even then it's far more attractive to claim the equivalent to married exemption. After doing the calculations you'll find that the EQM translates out as an $850 federal tax credit ($1,275 combined). As a result, the EQM means a savings of $1,100 to $1,200 in taxes owing.

By the way, this tax credit is not limited to children. However, under tax reform there are substantial restrictions as to who can be claimed. In the past we could claim virtually any relative provided we supported them and they lived with us or in a res-

idence provided by us. Now, however, we are restricted to claiming a child who is under the age of 18 or infirm or we can claim a parent or grandparent. No other relatives are acceptable unless it can be proved that an aunt, let's say, was the ''effective'' parent of the taxpayer.

When claiming a child as the equivalent to married tax exemption it's generally better to claim the youngest child. The older children will soon exceed the $500 net income that's allowable before this deduction is restricted.

13

Marriage Doesn't Always Pay

While marriage is a very strong institution, it appears that Revenue Canada is prepared to give more tax breaks to single taxpayers than to those who tie the knot.

For example: When a couple is married the higher-income spouse is now restricted when he or she tries to income split with the lower-income spouse through investment loans. However, when a couple lives together without marrying, there are no such restrictions.

Another case involves day-care deductions. With a married couple, the two incomes must be considered to see who gets the tax relief. Then it's the lower-income spouse who gets to claim. Effectively, unless both spouses work the family gets no tax relief for daycare.

A similar case can be made for the child tax credit. When two spouses are involved, their incomes must be combined to see whether or not the family exceeds the threshold level. Above that level their child tax credit is reduced. However, when couples live together they needn't combine incomes.

When a father and mother raise a child while living together without marrying, Revenue Canada now considers some of these tax deductions on a married basis. However, when couples live together without marrying and raise children by a former and different relationship, they get tax deductions as if they were single.

And don't forget to add in the equivalent to married exemption. It allows single, separated or divorced individuals to claim a child or another relative as a tax exemption equal in size to that reserved for a spouse. A single parent, then, can get the same relief as if he or she were married, provided a relative is being supported.

14

Family Problems Can Cost and Be Taxing

We live in a time when many families decide not to fight an uphill battle. They throw in the towel and move to two separate residences.

When that happens there can be some tax relief for maintenance or support payments made — but only if they are set up properly. Far too many families make private arrangements to handle these payments so that they can save some legal bills, but that can be a costly mistake. When it comes time to file a tax return and claim these expenses as tax deductions, they find that Revenue Canada has disallowed them.

The law states that alimony and maintenance payments can only be tax deductible if they are the result of a legally binding written agreement or a court order. Either normally requires some legal advice so why not see a lawyer in the first place?

You can sit down and iron out your own agreement without the help of a lawyer. But then you should take it to somebody in the legal profession to ensure that it's set up properly. The fees will be small this way. Rather than using a lawyer as a referee to arrive at an agreeable settlement, you can arrive at it yourself and use the lawyer to confirm it.

If you don't have a legally binding agreement, you'll find that Revenue Canada will deny the individual making the payments any tax relief and they may still find the recipient taxable. As a split family you don't want to share three ways; two is bad enough.

15

Always Let Lower-Income Spouse Keep Earnings

Recent federal budgets have done their best to eliminate income splitting, but they haven't been totally successful. In fact, there are quite a number of income-splitting techniques still available.

For example, you should do your best to let the family's savings grow in the lower-income spouse's name. That way the income earned by that spouse will be taxed at his or her lower tax rate rather than at the higher tax rate that may apply if it were left in the higher-income spouse's name.

One of the easiest ways to do that is for the higher-income spouse to pay all the family bills and all the lower-income spouse's bills. That includes his or her taxes, benefits, travelling costs, etc. That way the lower-income spouse will be left with his or her entire gross salary. It can then be invested to produce income that's taxed at a low rate.

We used to give or lend money to a lower-income spouse to accomplish the same result, but Revenue Canada now frowns on those practices. This can accomplish just about as much good, though, when there are two working spouses.

Before tax reform we could each earn $1,000 in tax-free investment income. As a result, it wasn't as important to practise income splitting if we didn't earn any more than $1,000 through investing. Now that we can no longer earn any tax-free investment income it's even more important that we accumulate monies in the lower-income spouse's name. Let's face facts. If we have to pay tax we might as well pay it at the lowest rate possible.

16

When Inheriting Money, Put It in the Right Person's Name

In most cases inherited money arrives tax free. It may have been taxed as part of the deceased's estate but generally arrives in the receiver's hand tax free. From then on, though, Revenue Canada hopes to extract its ounce of flesh as it will tax any investment income earned once the money is invested.

That's why it pays to receive any inheritances in the right person's name. For example, when a family inherits money it pays to split it evenly between both spouses where possible. That way one-half of the yield will be taxed in the lower-income spouse's name, if, in fact, it is taxable at all. Don't forget that even though we no longer have the $1,000 investment income deduction we can earn more than $6,000 in total income from any source before we are taxable. In addition, choosing invest- ments that produce dividends, capital gains or rental income can allow us to earn substantially more before we are taxable. The dividend tax credit allows us to earn as much as $22,000 in tax- free Canadian dividends each year, the capital gains deduction allows us to earn as much $100,000 tax free in a lifetime and rental income can be offset by the expenses associated with oper- ating the building and capital-cost allowance when it is profitable.

The other consideration, of course, is long term. If one spouse is going to have a much better pension than the other, this type of tax planning can pay off in future years. Now that tax reform is going to eliminate pension rollovers to our registered retirement savings plans we know that our pension income is going to be fully taxable except for the pension income deduction. Arranging to have future investment income mature in the name of the spouse who has a small, or no, pension will mean that income will be

taxed at a lower rate. Don't forget that when your spouse qualifies for the Old Age Security Pension that he or she will automatically be lost as a tax deduction. As a result, you should be doing your best to arrange your finances so income is generated in each spouse's name.

That's why it's important to take the time to sit down with a financial advisor, accountant or tax lawyer before you receive and utilize any inherited monies.

It may even be possible to put some of the money into your children's names where it can earn even more investment income tax free. Or you may want to aim for tax-free capital gains.

All of this, of course, may not be important. You may need the money to pay off your bills.

17

Transferring Deductions and Credits Can Save You Money

Oh, to have the joint tax return offered in the United States. Then, families where one spouse earned substantially more than the other could average their tax rates — and pay less tax.

Unfortunately, we don't have this facility in Canada. However, there are a few things we can do that will bring us closer to having a joint return.

When two spouses have incomes where one is substantial and the other is very small, we can often transfer some unused deductions from the lower-income spouse's name to the higher-income spouse's return where those deductions will produce substantial tax relief. In addition, there are some cases where tax deductions and credits that are not usable by students can be transferred to a parent or spouse's tax return to create extra tax relief. The situation we're looking for has one individual qualifying for tax deductions or tax credits that they don't need or can't use. Once we have that scenario we can try to transfer that tax relief over to somebody else's tax return.

In most cases we have to look at Schedule 2 when it comes to transferring tax deductions from one spouse to another. Section A of this schedule helps us calculate our spouse's income. Basically, we're looking for the investment income our spouse earned after deducting any investment expenses, his or her pension income, and any other forms of income.

Section B helps us calculate the amount of deductions that can be transferred from a spouse's tax return to our own.

The first deduction is the age exemption. If your spouse was 65 years of age or older at anytime in 1988 you might be able to claim as much as $2,640 in tax relief. Remember, even if your

32

spouse turned 65 on New Year's eve you might be able to use
this deduction.

The second consideration is the disability deduction. It's worth
$2,890 on this tax return. Your spouse will qualify for it if he
or she suffered from an illness last year that markedly changed
his or her lifestyle. It must have lasted for 12 months or will last
for 12 months, but it's no longer required that your spouse be
bedridden or confined to a wheelchair for most of each day. In
addition, if you have not claimed this deduction before you must
acquire a doctor's certificate.

If your spouse attended an approved educational institution and
took a large enough workload to qualify for a T2202 or T2202A
you should total $50 per month times every month he or she
attended school full time. Remember, though, that your spouse
must be able to obtain approval from the educational institution
that he or she attended enough classes to be considered full time.
The good news is that the requirements needed to meet that
objective have been eased retroactively for 1988.

The investment income deduction was phased out for 1988 and
subsequent years. However, it could still be used on 1987 or
earlier tax returns if you haven't filed them yet. If your spouse
doesn't need all or any of his or her deduction, enter the usable
amount on line 13. The pension income deduction is changed to
a tax credit for 1988. Again, if your spouse doesn't need any or
all of this deduction, record the amount on line 14.

Now you will be able to determine whether or not you can use
any of your spouse's unused tax deductions to lower your tax
bill.

Remember, to qualify for this transfer of deductions it's nec-
essary that your spouse's taxable income be reduced to zero.
That's the amount recorded on line 260 and line 400 of your tax
return. If your spouse has some taxable income and part of the
deductions discussed here will lower his or her taxable income
to zero, you should do the necessary calculations to lower that
person's taxable income to zero and transfer the remainder to
your tax return.

You'll also notice that there are three lines where you can transfer over unused deductions from another taxpayer. Line 251 is the one where you transfer over unused deductions from your spouse's return. They are all calculated on Schedule 2 — Deductions Transferred From Spouse. However, when a dependant other than your spouse is involved you must use lines 246 and 247. The former allows you to claim a disability deduction for a relative you support, as long as that relative doesn't need it to lower his or her taxable income to zero. When a student who qualifies for the $50 per month full-time student deduction is involved, you can transfer over the portion not needed to lower his or her taxable income to zero to your tax return on line 247. Unfortunately, many students think they aren't taxable so they don't complete a tax return. Their parents don't communicate with them, so they don't realize they could be claiming the unused portion of this deduction. And, there are many cases where a student earns just enough to eliminate the transfer of these deductions. They aren't taxable, so they don't bother contributing to an RRSP. However, if they had, they would have created equivalent-sized tax deductions on their parents' or spouse's tax return.

If your spouse earned Canadian dividends, but didn't earn enough to be able to use the dividend tax credit, you should look at transferring all your spouse's dividends and all the dividend tax credit to your tax return. However, it's an all or nothing situation. You can't transfer over part of the dividends.

While this section of the return isn't always used because of its complexity, it should be used by more taxpayers. It can save you paying taxes that are rightfully yours.

18

Child Trusts Are Not Over After All

Many people like to say that Revenue Canada has stopped the practice of income splitting with children, but it just isn't so. In fact, it's very much alive.

In the past we used to lend money to our spouse so that our spouse could invest it and be taxed at a lower rate in his or her name than if we had kept the money in our own name. And when we had children, we'd open child trusts in their names and lend the trusts money. The trusts would earn money that was taxed at the child's lower rate. As a result, the family saved on taxes.

Well, regardless of what you hear, child trusts are still very viable. In fact, they're a growth industry with the legal profession as lawyers can very easily save many families a ton of taxes.

Here's how they work. The child should be 15 years of age or older. The parent opens the trust and lends as much free capital as they have into the trust. Once in the trust the money is invested in something that won't produce any yield for at least three years. That's important, as once a trust produces income for a minor that income must be taxed in the parent's name. However, if the income is compounded until the child turns 18, it won't show up in the child's name while he or she is a minor. That means it will be taxed at their low rate rather than at the parent's higher tax rate.

From 18 on we don't have to worry. All of the income produced by the investments held inside the trust will be taxable at the child's low rate. Children can then use the money to pay for their education, to start a business of their own, to take trips overseas. In fact, they could even use it to pay room and board. It's a lot better for them to pay it themselves rather than for parents to be

on the hook. The parents will pay these bills out of money that's left over after they pay their taxes. The children will be taxed at a much lower rate, if in fact they are taxable at all. That leaves more money for the family's use.

Fifteen is the important age if you're determined to use interest-bearing investments. They can be compounded for no more than three years before they become taxable. However, if you were prepared to put other investments in this trust you could start earlier. Capital gains earned by a trust are taxed in the child's name, not the parent's. And some investments produce no yield in the early years. They simply rise in value. If you didn't sell them there'd be no tax problem. Once the child reaches age 18 you could sell them. By then, though, the tax bill would be in the child's name, not the parent's.

Investments that would qualify include real estate, the stock market and mutual funds. They can all produce low yields but substantial capital gains.

19

Let Everything Grow in Your Child's Name

Revenue Canada has done a pretty good job of restricting the practice of income splitting, but here's a way that you can still use it.

When we transfer money to a spouse's name or to a minor, the "attribution rule" says that we have to claim the income earned on these monies in our own names. So why bother transferring money to anybody else's name? Well, there's a very good reason.

It's true that income earned in this way is taxable in the donor's name. But if there's no income generated we don't have a problem, and according to the attribution rules, capital appreciation isn't considered income. That means transferring a pile of money to a child won't present any tax problems if the money earns only capital gains.

Realizing that, what if we transferred enough money to a child to buy a large piece of property on the outskirts of town? The property wouldn't produce much income unless it was rented out to a farmer — and even then there would be property taxes and other expenses that could be used to offset that income.

Between the time this property was purchased and the time when the property was sold, there would be a reasonable opportunity for it to rise in value. Generally, of course, that's what happens. Land on the outskirts of town rises in value as the town expands. In this case, though, the gain will be tax free or taxed at a lower rate in the child's name. This way the family saves on taxes.

20

Summer Camp Can Be Tax Deductible

Many parents spend time in the winter and spring months looking for a summer camp for their children. Then, when they send them to summer camp they forget all about the fact that they may have been able to get some tax relief.

You see, if you send a child to a day-care center or bring in help so you can work, earn income and pay taxes, you are entitled to claim the cost as a tax deduction. Well, the same theory applies to summer camp. Effectively, you should consider that you are sending your child to summer camp rather than paying for child care. As a result part of your cost will be tax deductible.

There are a few rules to meet, though. The first is that both you and your spouse must work, if you are married. If you are a single parent there is no problem, unless you live with the other parent of the child. In that case you are considered married when it comes to claiming child care or summer camp. There are three exclusions to this set of rules. One works once in a while but is of no use to most of us; the second and third can be of more value. The first example allows a married parent to claim child-care expenses when his or her spouse is confined to jail. Surely, most families are excluded. The second alternative is to have one spouse enroll in an occupational training course for which he or she gets a training allowance under the National Training Act. The third choice involves one spouse carrying on research or similar work for which they received a grant. If you are married or live with the other parent of your child the last two examples may allow you to claim child care and in this example summer camp fees as a tax deduction even though only one spouse is taxable.

You see, that's one of the major problems with child-care expenses. The lower-income spouse must claim the child-care expenses on his or her tax return. If one spouse has no income the family as a whole will not qualify for tax relief, unless, of course, you fit into one of the exclusions mentioned above.

If you meet these requirements, how much tax relief can you get? Well, under the new rules we are allowed to claim up to $4,000 for each eligible child who was six or under on December 31 of the taxation year. We also get $4,000 for each child who was over six who had a severe and prolonged mental or physical impairment and $2,000 for each other child from seven to 14 years of age.

Now, how does summer camp fit in? If you can justify that you sent your child to summer camp rather than to a day-care center you're home free. And, many parents will be in this situation. During the school year they may send a young child to nursery school or an older child to a center after school until one parent gets home from work. More companies now provide day-care assistance at work so their employees can be more productive.

Come the summer months, though, a problem often develops. The elementary-school student is on summer vacation. Now the parents have to find daycare. One choice for part of the summer can be summer camp. It can be hockey school, computer school, you name it. But there's a legitimate argument that daycare is involved. In fact, the camp doesn't have to be a long distance away. It can be a day camp where you still have your child with you at night.

In these examples you are entitled to claim up to $60 per week in tax relief per child. For a family with two children that can mean a savings of $50 to $60 a week. It may not seem like an awful lot but every little bit helps.

If you find a summer camp for your children ask the sponsor if their camp qualifies for this type of tax relief. If it does you will want an acceptable receipt. You don't have to file the receipt with your tax return but you will have to document the expense and may be asked to produce the receipt later.

21

Charging Your Child Room and Board May Save Taxes

Lots of parents have older children who still live at home. It's not unusual for them to charge room and board to those children. When they do, Revenue Canada takes the stance that the monies received aren't generally taxable. They aren't tax deductible for the child and not taxable for the parent as you're not really trying to make a profit. All you're doing is providing space in your home for family members.

In fact, to protect themselves Revenue Canada doesn't allow family members to claim tax deductions in excess of revenues when they rent properties to other family members.

We can use this information to our advantage. Let's say you have some investments that produce taxable income. That is, you own interest-bearing investments, dividend-paying stocks or mutual funds or you've already claimed your $100,000 tax-free capital gains deduction. At the same time, you have a child who earns no income or very little. If you gave some money to that child he or she would be able to invest it and earn tax-free investment income. I know we can no longer earn $1,000 in tax-free investment income but if your child doesn't earn much income now all you'd have to do is give him or her enough principal so they wouldn't earn enough to make them taxable.

If, for example, you gave your child $10,000 he or she could invest it and earn $1,200 a year or more. That wouldn't be enough to make the child taxable and it probably wouldn't be enough to even eliminate the child as a dependant tax credit on your return. You've successfully practised income splitting. However, if you went one step further and charged your child $1,200 room and

board you'd get back the $1,200 free of tax since room and board between families in this example is tax free.

This practice is easiest when the child is 18 or older. The child is an adult and can legally enter into these transactions. However, there are ways to accomplish the same or similar results with minors. If you have a trust in place it's easy. If you don't it will be more difficult.

22

Saving for Your Child's Education Can Save Taxes at the Same Time

If you have children, you may want to investigate the idea of a registered education savings plan rather than saving money in your own name. Money saved and invested by parents will produce taxable investment income. And that is sure to happen if you are to save up enough cash to send your children on to higher learning.

If you transfer money into a child's name there's no tax, but the income earned by that money will be taxed in the parent's name, not the child's. However, if you use an RESP — like Canadian Scholarship Trust Fund or University Scholarships of Canada — the money you contribute will accumulate in the child's name rather than your own. In fact, there's no tax at all until the money starts to come out in the child's name. By then, though, the money should have grown faster in a tax-free environment rather than in your own name. In addition, the money will come out of the plan taxed at the child's lower tax rate rather than your higher one. That is, of course, if the child is taxable at all. His or her income will be low at the time plus there are the tuition and full-time student deductions to offset other income.

There are also other much more flexible registered education savings plans offered by stockbrokers and financial planners. They allow you to contribute more than $30,000 per child into one of these plans. Yes, there's no tax deduction when you contribute this money. But, all the earnings inside the plan compound totally free of tax for as long as 21 years. You are always guaranteed the right to remove the amount you originally con-

42

tributed completely free of tax. The earnings will be removed in the child's name and taxed at his or her tax rate. Don't forget though that your child will have tuition, the full-time student deduction and their personal exemptions to offset or eliminate their tax bill.

With this type of RESP you have much more flexibility. You can put in as much or as little as you want, you can pick and choose the investment you use at any time you want and you can remove the money whenever you want. In fact, if your child decides not to attend college or university you can name another beneficiary — including yourself, just in case you want to go back to school sometime in the future.

23

It Doesn't Always Pay for the Father to Claim Junior as a Dependant

Normally, the father will claim the children as tax exemptions. But that's not always the right thing to do, especially now that we have more families with two working spouses.

There's nothing that says the father has to claim the child as a dependant. Either parent can. In fact, any relative who supports a child can claim that child as a dependant in many cases.

Recognizing that, the parent with the higher taxable income should claim the dependants as tax exemptions. The higher the tax bracket, the greater the tax advantage when you get a tax deduction.

There are cases where the lower-income spouse should claim the dependants, though. For example, if a child has a part-time job and is going to be partially lost as a tax exemption, the lower-income spouse might as well claim the child as an exemption. The parent claiming the child also has to add the family allowance cheque to his or her income. It's okay when you get a full dependant exemption. However, when the exemption is lowered because the child had a partial income, the dependant exemption will be diminished even though a family allowance cheque will remain at full value. In that case it's a valuable exercise to compare the tax advantages of having a child or children claimed by the lower-income spouse rather than in the name of the higher-income spouse.

24

You and Your Child Can Benefit from Borrowed Money

It's not often that we think about borrowing money for a child, but it can be a valuable exercise. We know our children have a regular income, and that's all they need to establish a line of credit. In addition, we know that they are generally debt free, so why shouldn't a banker lend them money?

The answer is that they're minors. They don't have the right to enter into a legal contract. However, if we borrowed the money for them they could service the interest cost with their regular income — their family allowance cheques.

That's right, the family allowance cheque belongs to the child. In fact, any investment income earned on money we give a child is taxed back in our own names, but investment income earned by investing the family allowance cheque is taxed in their own names.

The problem with the family allowance cheque is that it's a rather slow process to invest by the month. Instead, you could borrow three thousand dollars or so for the child and let the family allowance cheque pay off the loan each month. That way your child has a much larger pool of money invested right at the outset. That pool of money will grow faster than if you started out with a much smaller amount.

Because the child is a minor you'll have to put the money in your name. However, if you use the proper ''paper trail'' you'll be able to document that the loan was taken out for the child and the money invested for his or her benefit.

25

The Baby Bonus Is Really the Baby's

When the family allowance or baby bonus cheque arrives in the mail, it's meant for the use of the child. For some families that means buying clothes and other items the child can use. For others, there's room for investment.

Revenue Canada's policy is to have the parent who claims the child as a dependant also claim the baby bonus cheque as taxable income on his or her tax return. In the past, that was generally the father. However, with more two-income families it is no longer always the case. In fact, in a single-parent family it's pretty clear which spouse will claim the child and also pay tax on the baby bonus cheque.

While it's impossible to avoid paying tax on this income — unless you aren't taxable — it is possible to use the baby bonus cheque to produce tax-free income.

For example: If you have the ability to put the money away for the child's future use you'll often find that you can't open a savings account for the child. Because the child is a minor, the institution will normally ask that the account be opened for the child in the mother's name. But that can create some very taxing problems. The institutions often send the T5 tax slip to the mother each year — and she often makes the mistake of adding it to her other investment income when she files her tax return.

Don't do that. You may end up paying tax on money that was actually earned by your child. Instead, you should claim it on the tax return of the individual who claims the child as a tax exemption. Simply claim this income as net income of the child when you calculate the child exemption. That way it's earned tax free in the child's name and is allowed to compound for many

years rather than being taxable on the mother or father's tax return.

26

Winning a Scholarship Not Only Helps with Schooling — It Saves Taxes

Considering the cost of going to school, parents would love to see their children win a scholarship or bursary. It would help offset some of the expense.

It can also mean a tax savings, in that tuition fees are tax deductible only in the children's names and not on the parent's tax returns. That means that any savings to the parents are the same as earning tax-free income.

Bursaries and scholarships can also be tax-free income for the children. In the first place, the first $500 is considered tax-free income. In addition, the student will qualify for the normal deductions and exemptions, plus the $10 per month full-time student tax credit. And tuition and moving expenses are tax deductible on the student's tax return.

Tuition is an easy one. It's always been tax deductible on the student's return. However, moving expenses provide the surprise. When a student moves home in the summer months, the travelling expenses are tax deductible against income earned in a summer job. But when a student moves back to school, the moving expenses are not tax deductible unless they are claimed against bursaries or scholarships. Once again, the winning of a bursary or scholarship has saved taxes as the first $500 is tax free and some or all of the rest is offset by the cost of getting back to school.

And don't think that a few hundred dollars worth of deductions isn't important! If you can lower the child's income far enough so that the student doesn't need to claim the $10 per month full-time student tax credit, it's transferable to a parent's tax return.

As a result, savings like these can save taxes not only for the students but also for the parents.

27

Why Not Get Paid to Look for a Job?

We've all heard of moving expenses, travel expenses, investment write-offs, and a myriad of others. But how many have ever claimed job-seeking expenses? The answer is very few. The reason, quite simply, is that few of us realize they exist.

If an employee spends money looking for a new job, he or she seldom gets any tax relief. However, if an employer spends money looking for new staff, he or she can indeed claim those expenses as tax deductions. So why not combine the two individuals to save a few tax dollars?

Spend your time and energy looking for that new job. Once your prospective boss is sold on hiring you, you probably have a little negotiating room. So why not ask for job relocation expenses? They could include the cost of moving you and your family closer to the new job — or they could simply cover your cost of looking for this new job.

Either way these are tax-deductible expenses for the employer. In the case of moving expenses, it's pretty cut and dried. With job relocation expenses, though, it's a little more complicated. Your boss will be committed to paying you a salary. It's a tax deduction, as would be moving or other expenses. Why not ask your employer to pay you moving or job search expenses, rather than salary, as these forms of income are tax free to you whereas straight salary would be taxable.

Actually, it makes very little difference to your employer. Both expenses are tax deductible so he or she doesn't pay a cent extra regardless of which way you receive the money.

28

If You Work Outside Canada, You May Get a Tax Credit

It's not unusual for major companies to transfer employees outside our borders from time to time. When that happens, it can open the doors to double taxation — in Canada and in the country where the employee works temporarily.

To offset this problem, Revenue Canada in some cases allows a special tax credit worth up to $80,000. In most cases that should be enough to solve this problem, and in many it might be a great way to earn some tax-free income.

To qualify, you must work in certain fields. Included are construction, agriculture, the exploration for oil, natural gas and minerals, and activities in the engineering field. If you're involved in any of these fields for a Canadian or Canadian-related company, and you work outside our borders, you should speak to your employer about these special tax credits.

In addition, these tax credits aren't limited to taxpayers who work outside the company permanently. If you spend most of the year working in another country you may still qualify on a proportionate basis. All you have to do is compare the number of days working outside the country to 365. If you worked two-thirds of the year outside the country, two-thirds of the maximum $80,000 tax credit would apply.

Before you jump for joy, though, talk to your employer to make sure your company, your job classification and your income qualify.

29

"Own" Your Boss and Save Taxes

If you believe in the company where you work, you should look at getting some stock options. They allow you to buy shares at a preset price at some point in the future. In the meantime, if you work for a closed corporation — that is, a company that doesn't trade on major exchanges — you've locked in these shares at today's price without incurring any tax liability. And, when you exercise your options, you still won't create a tax problem. That only happens when you sell them — and even then you might get another break.

By the way, if you work for a company whose shares do trade on a major exchange, you also have no problem when you get your options. However, when you choose to exercise them you can find that the difference between what you paid for the shares and their fair market value can be added to your income in the year when you exercised. Even then, though, paying tax on the excess is better than paying the excess itself.

There's one other point that should be considered. To continually buy and sell these shares would be a no-no in Revenue Canada's eyes. As a result, you must keep your shares for at least two years when you do exercise them. That way you won't be taxed when you get them and any gains earned when you sell them will be considered a capital gain. Depending on the year when you sell, you could qualify for up to $100,000 in tax-free capital gains.

In the meantime, though, options are an excellent way to profit in future corporate growth without having to pay much cash up front or pay much tax down the road.

30

Having a Company Car Can Be a Taxing Ride

If you are supplied with a company car, you may have to add something called a standby fee to your income and pay tax on it. Revenue Canada feels that most of the employees who get company cars use them for both personal and business purposes.

If you, for example, drive your car more than 12,000 kilometres a year you can be nicked with a $2,400 taxable benefit on a $10,000 car. Depending on your tax bracket, you'll pay $100 a month or more to Revenue Canada for the right to drive this car.

Another option, if your employer will entertain it, is to have him or her lend you $10,000 interest free. You'll have to add $1,000 or so to your tax return for imputed interest (interest you saved by getting an interest-free loan is a taxable benefit). But you'd only have to pay about $500 in tax rather than $100 a month the standard way.

Of course, you'd also have to operate the car. To cover those costs you should arrange to bill your employer the going rate per kilometre. In most cases those expenses would be received tax free as they were incurred in the course of doing business.

There's one other consideration. You own the car, not your employer. As a result, you want to make sure that you save the tax savings and expense gains so you can accumulate enough to pay off the loan.

If you do that, you should end up owning the car in a few years. Eventually you'll be able to trade it in and start all over again. That is, if your boss is interested.

31

A Benefit Is Not Necessarily Taxable

Most of us don't get much in the way of tax relief when our employer gives us some extra benefits.

But what if you are forced to take something that you don't want? Well, that benefit may not be taxable after all. Revenue Canada is actually pretty fair. If you are a senior executive with a company that's worried about your well-being, so much so that they hire a bodyguard and provide a big black limousine to protect you, that won't always be treated as a taxable benefit. You should check with your employer or tax specialist to make sure that you don't pay tax when you don't have to.

Other examples include the obligation to put on major parties or suppers at your home. If the company reimburses you for the food and drinks you provide, or catering, there's not necessarily an obligation on your part to claim a taxable benefit.

In these examples Revenue Canada will look at whether you benefit or whether your employer benefits. For your sake, the answer will hopefully be that the company benefits more. That way it will get a tax deduction and you won't have a taxable benefit.

32

If Your Boss Dresses You, It Might Be an Untaxing Experience

Most taxpayers used to get some tax relief to help offset the cost of doing business. The rationale was to give employees a small tax break when they had to buy their own tools, safety shoes, uniforms, etc. It was called the employment expense deduction and offered a $500 a year automatic tax deduction. Unfortunately, Ottawa has eliminated that tax break as part of its tax reform plan. As a result, taxpayers who are considered full-time employees, that is, they are not classed as self-employed individuals, now get no tax relief at all for the cost of items they are forced to provide in their job pursuits.

Those who work at jobs where they have no obligation to provide special items were getting a gift so they shouldn't really object to the loss of this deduction. However, those who are obligated to provide certain items to get or keep their jobs are at a definite disadvantage. They now continue to make the expenditure but get no tax relief. Maybe, though, there is a way to get some tax relief.

Uniforms are a tax-deductible expense for an employer, so why not approach your boss about the possibility of having your uniforms supplied? That way you beat the loss of the employment expense deduction and may get a free uniform or two.

However, not every employer is prepared to pick up the tab for any extra costs. So why not try this idea instead? Ask your employer if he or she will pay the cost of the clothing if you'll take a pay cut of equal size. Your employer won't pay any more than originally planned and you'll get your clothes free and clear.

The advantage to you, of course, is that initially you had to earn the money, pay tax on it, and then purchase the clothing with after-tax dollars. Now you get the clothes free and your tax bill is lower. In fact, if your employer has any purchasing power, he or she may be able to buy the uniforms in bulk at a discount. In that case your salary may well be reduced by only a small amount. You come out a winner in the long run.

The only fly in the ointment in this idea is the fear of losing long-term salary growth. Let's say you make an arrangement like this to lower you income by $500 a year. If your boss gives you a 10% salary increase next year you might come out $50 (10% of $500) short if your raise is based strictly on your salary. Accordingly, it's important that you arrange for your employer to include this $500 as part of your salary when he or she gives you a raise each year.

33

Full-Time Workers May Still Be Classed as Students to Save Tax

Those who are full-time students qualify for extra tax relief that's designed to help them offset part of the high cost of attending school. Those who attend school full time qualify for the $10 per month full-time student tax credit — provided it's verified that they attend the required number of courses in designated institutions. Only institutions that offer courses beyond secondary school levels qualify though, unless it can be proven that the courses being taken are "trade" courses, and the institution is an approved one.

This is a very valuable tax credit in that it can either lower your own tax bill or lower somebody else's if you don't have any taxable income. As a result, every student should determine whether or not they qualify to use it — and I mean every student. You see, full-time employees may qualify to claim this tax credit.

A taxpayer who attended postsecondary school full time for part of the year and worked the rest of the year should claim for the number of months that he or she was attending school. That'll help offset some of the taxes owing as a result of his or her work-related income.

But, there's a way that we can use this deduction to save even more tax. If you work full time and take enough courses at the same time to be classed as a full-time student, you'll get the full $10 per month credit for every month you qualify. All you have to do is get the institution to confirm that you take enough courses to be classed as a full-time student and you've got it. In fact, when you think about it, many students who are taking post-graduate courses don't even have to attend classes. It's the work-load that counts, not necessarily your attendance. Ottawa has also

eased the requirements for full-time student recognition. As a result, it's now that much easier for full-time workers to also save taxes as full-time students.

34

Delay Accepting Income Whenever Possible

I know we want to earn as much money as possible, but there are times when we should consider refusing or at least delaying receipt of it.

Here's the classic example. It's late in the year and you're waiting for your production or sales bonus. You know it'll come very near the end of the year, and while it will be welcome you also realize that there's a slim chance you'll be able to spend it before the new year. If that's the case, why not ask your boss to delay it until the new year. Yes, you won't have access to it for a few more days or weeks, and yes, it's possible that you'll lose a little interest for that time period. But, don't forget that you also won't have to claim it as taxable income until next year — and you won't have to settle up with the taxman for another 14 months or so. Being able to invest the tax share for an extra 14 months will normally more than offset the loss of all the money for a few days or weeks.

When we work for an employer, he or she will normally withhold taxes from any earnings. As long as taxes are withheld on 70% of our earnings, we don't have to pay quarterly instalments on other income. We'll sort it out when we file our taxes. If you have other forms of income this planning can also pay dividends in another way. If you delay your bonus income until next year you may now be able to defer paying quarterly instalments on freelance income. Conversely, if you have not kept up to quarterly instalment requirements for this year, taking a bonus this year rather than next could save you having to pay some interest to Revenue Canada.

By the way, don't worry too much about your employer's

reaction when you suggest some tax-planning consideration at bonus time. The company's year end probably doesn't come on December 31 anyway, so delaying your bonus for a couple of days won't cost the company any tax dollars. In fact, they'll have the use of the money for a longer period of time.

You will be a happier employee and that's what every boss wants. You'll also be richer, and that's what every employee wants.

By the way, if your employer balks at this idea suggest that he or she look at using the same theory on his or her own bonuses. Then the reaction may be more positive.

35

Don't Pay Tax on Nontaxable Income

Tax reform is designed to eliminate many of the sophisticated tax deductions that high-income taxpayers used to save taxes. The trade-off, of course, has been to lower the tax rate we pay on our earned taxable income. As we lose exposure to making income nontaxable we may also be lulled into believing that all income is taxable. Such, fortunately, is not the case. In fact, there's a long list of tax-free types of income. Make sure that you aren't paying taxes on income that's tax free. If you have been, call your local Revenue Canada office regarding a reassessment. Income that's tax free includes:

- lottery and gambling winnings
- war veterans' allowances
- welfare payments
- inheritances
- veterans' disability and dependent pensioners' payments
- spouses' allowances, but not alimony
- workers' compensation payments
- guaranteed income supplements
- tax rebates, except interest
- child tax credits
- income earned by Indians on reservations
- capital gains earned from 1985 on (check maximums each year)
- proceeds from sale of principal residence
- life insurance proceeds on death
- injury awards
- board and lodging of employees at special work sites.

36

If You're Self-Employed, Don't Forget These Write-Offs

Revenue Canada has made substantial changes in the way self-employed taxpayers can claim automobile and office-in-the-home expenses. However, both (and many other legitimate expenses) remain deductible for those who are legitimately self-employed. It's imperative that every tax deduction is used to the fullest. After all, you know they will tax your income. If you incur expenses to earn that income, Revenue Canada should be prepared to pick up part of the cost in return for a partial share of the profits.

Following is a list of some of the out-of-pocket expenses you should not forget to use.

- Bank service charges and interest
- Couriers and delivery charges
- Entertainment and dinners for clients
- Accounting fees
- Advertising
- Business development expenses
- Office supplies
- Computer charges
- Car expenses including gas, oil, maintenance, car washes, parking, insurance, licences, interest and depreciation
- Depreciation on any equipment purchased for business use
- Telephone charges
- Postage and mailing costs
- Salaries for employees whether full- or part-time, including spouse and children

- Office rental expenses or expenses (in some cases) even if the office is in your home
- Seminar fees when work related
- Two conventions each year
- Tips and coat checking
- Cab fares, airlines, limousines, parking, including meters
- Legal bills when needed to collect outstanding bills
- Cleaning bills when away from home
- Investment advice
- Subscriptions when business related
- Books and stationery
- Gifts etc. when given to clients, potential clients or as incentives to employees

37

Why Not Get Revenue Canada to Furnish Your Office?

Anybody who's self-employed realizes that office expenses are tax deductible. That includes rent, utilities, maintenance, etc., plus the cost of any equipment you may need. Large items like desks, typewriters, computers and so on aren't tax deductible all at once; they must be depreciated over a number of years. All the same, though, they do provide us with some tax savings.

But what if we buy antiques and antique-type furniture that will rise in value, even though we know we can depreciate them? We'll end up with tax deductions for the years we own them, and according to the new capital gains rules we'll be able to sell them totally free of tax as long as we're under the $100,000 maximum. In addition, if we really play our cards right, we'll borrow to buy office furnishings while we use our cash to pay off non-tax-deductible personal loans. That way the interest is also tax deductible — another tax deduction. It's a nice way to furnish an office, including antique desks and rugs, art and other artifacts at the same time as we get some tax breaks.

Here's the fly in the ointment, though. Corporations don't qualify for the tax-free capital gains holiday. That means that only those who run non-incorporated businesses qualify. But there are hundreds of thousands of self-employed Canadians who will. In addition, there are many employees who could encourage their bosses to buy antiques for their offices. The company gets the tax write-offs with the equipment being sold to the employees at book value or cost at a future date. It's an interesting perk, isn't it?

Revenue Canada is making it more difficult for taxpayers to claim an office in their residence as a tax deduction.

You must actually produce income while working in that office.

Revenue Canada has long complained that a stockbroker, for example, did all his or her work at the company's office or on the road. There might be research done at home but that wasn't enough to justify tax relief. As a result, they now have put some teeth into the office-in-the-house regulations. To satisfy them we now have to see clients in this office or produce goods or services right there on the spot. In addition, we can only claim the expenses we incur against the income actually earned while operating this business. In other words, we cannot create tax deductions against other forms of income because our little "in-house" business was running at a loss. However, we can stockpile these office expenses and use them in future years to offset income earned when the business is more profitable.

38

Pay Up Early and Save Taxes at the Same Time

We all know that businesspeople get to claim their expenses as tax deductions. But when they pay them it can make a big difference taxwise.

Let's say you run a small unincorporated business or are self-employed. Your present vehicle is tax deductible but you've been thinking about buying a new one. What better time than right near the end of the year? Revenue Canada uses something called the half-year rule. That is, you only get to write off half the normal depreciation in the first year. But we're well past half year as the year winds down, so being able to get half the full-year tax deduction is actually a bonus.

As a result, it can pay to look at a new car or truck right near the end of the year. You get part of the depreciation allowable on your old vehicle plus one half the first year's depreciation on the new one. The older vehicle is probably worth very little as a tax deduction because you've been writing it down over a couple of years. The new one can create some substantial tax relief, though, even if you only bought it on New Year's Eve.

If you don't have the cash you can always borrow the money. The interest will be tax deductible if the vehicle qualifies as a business vehicle and so will the other closing costs.

The example we've used is a car or truck. However, those who qualify for tax deductions of this type could also benefit by buying computers, office equipment and other legitimate types of business equipment as the year comes to an end.

39

Does Buying a Year in Advance Save Taxes?

Businesspeople, whether incorporated or not, can use some equipment purchases as tax deductions. That's prompted some taxpayers to load up on everything they can just before the year ends so as to create extra tax deductions.

They would have purchased the goods early in the new year anyway, so they would have created a tax deduction at that time. As a result, it makes good sense to load up in advance. The tax break comes right away rather than at the end of next year.

Well, Revenue Canada has been catching on to this trick. They're not particularly pleased when you claim interest, rent, insurance and property taxes before their due date. So they may refuse to accept prepaid expenses in this category.

There are expenses, though, that should qualify. For example, if you buy some office stock that you know you'll use in the future, you have a pretty good chance. If you buy equipment at the end of the year that you can justify that you'll need early in the new year, or if you pay insurance premiums once a year rather than by the month, you probably have little problem in these cases.

Revenue Canada is fair. If you can justify the expense, they'll accept it. If you can't and if it looks like you're trying to beat them, they'll put a stop to it.

Whether you're self-employed or running a family business, you should seek out every tax break you can. It's better to claim a deduction and be refused than to have never claimed something that could have been accepted.

40

Don't Forget the Past and Future When Claiming Losses

Nobody wants to run a business at a loss, but in some cases it can be very beneficial not just for the present tax year but also for past years' tax returns and the future.

If you run an unincorporated business or share in a partnership that loses money in a year, be sure to claim those losses as a tax deduction against any other forms of income you had during the year. That includes pension, investment and other work-related income.

However, if the losses exceed your other forms of income, you don't have to stop there. You can carry them back and claim them against any of the last three years' incomes or forward for as long as seven years.

The advantage here is that you can pick and choose between as many as 10 years when deciding where you want tax relief. First, you should look at three years ago as next year you won't be able to include it. It'll be four years ago by then. But don't let that be your only consideration. Your tax bill may have been substantially greater only two years ago, or last year for that matter. And even then you may feel that you will be in a substantially higher tax bracket in coming years. If that's your feeling, you may want to forget about the last three years and save these losses for future use.

By the way, you won't have any income. So make sure your spouse claims you as a dependant along with the children and also claims charitable contributions and other deductions.

When you look at this idea it's important to do some projections as to your future income. If you believe your income will be lower in future years you'd want to use up your tax deductions

now when your rate is high. Conversely, if you believe your tax rate will be much higher down the road there is a case to be made for hanging onto these tax deductions for future use.

The other consideration is tax reform. There is a strong belief that when stage two of tax reform is implemented our top marginal tax brackets will fall. If you believe that you'd want to use up your accumulated tax deductions before the lower tax rates were introduced.

41

You Can Hire a Family Member, But It's Easier to Employ a Friend

Self-employed individuals, or those who run a small business, can, if they wish, pay their spouse a salary. It's an excellent way to save taxes in that all of the family's income isn't earned in one spouse's name.

For example, an individual may run a small, unincorporated landscaping business. If the business is profitable, the operator will be able to claim operating expenses plus salaries and other deductions to offset that income. If his or her spouse is included in the salary picture, it's the same as income splitting. The profits will be less so there'll be less tax to pay. Part of the reason is that his or her spouse earned part of the profits and they were taxed at that taxpayer's lower rate.

Where this idea really pays off is when the small business doesn't make a profit — especially when it isn't an incorporated company — and when the operator runs it while working full time somewhere else. In that case, he or she can claim the losses as a tax deduction against the other forms of income, including a salary, investment income and pension. In this example, then, a highly taxed wage earner with few deductions can save taxes by opening a business on the side. By paying his or her spouse a salary, his or her normal tax bill will fall. At the same time, the spouse will earn an income but it will be taxed at a lower rate than the tax savings created in the first place.

In addition, salaries paid to children in this way create similar tax savings. In fact, though, it's even easier if you aren't married. Then you can pay a common-law spouse, let's say, in the same

fashion. However, the restrictions that apply to setting up this business relationship are less restrictive when it involves somebody other than a spouse or a child.

42

How Would You Like a Tax-Deductible Vacation Every Year?

Self-employeds and commission types get a major break from Revenue Canada in that they get to write off the expense of attending two conventions each year if they want to.

Naturally, these conventions must meet certain criteria, such as having a direct connection to developing business or a better understanding of your business — and they can't be held in exotic locations like Hawaii without justification.

If the conventions meet Revenue Canada's guidelines, though, attending them can cut your vacation costs substantially. Let's say that you have a small landscaping company. The industry's annual convention is being held in Banff this year and you've never been to Western Canada. What better opportunity than to attend the conference where virtually all your expenses will be tax deductible? And better yet, if you stay over for an extra week most of your expenses for that week will also be tax deductible. Even though you aren't on business any longer your airfare or other transportation costs will still be tax deductible. The only out-of-pocket costs that won't be are food and lodging. In fact, they may still be a deduction if you can convince Revenue Canada that you were seeing suppliers or developing future business.

While you're on this trip, part of your spouse's expenses will also be covered. If you drive, there's no extra cost as it's only another seat in the car. And once you get to the hotel, it's only another person in the room that you had to pay for anyway.

Where you come out even further ahead is when your spouse works with you in your business. When that happens both of you are entitled to attend two conventions each year. That means you either get extra tax deductions for two conventions or each of

you tags along with the other on four partially deductible trips each year. It's a super way to get in some travel and some tax relief at the same time.

Here's a further advantage that may help many individuals. If you work full time at your regular job, but have a small business on the side, you can qualify for the very same tax relief if you attend a convention or two each year. However, if your little venture doesn't always make a profit, these and any other business expenses can be carried forward and used to lower the tax you were going to pay on your ordinary income. You see, even those who aren't totally self-employed can get tax breaks this way.

Under tax reform, Revenue Canada will be more restrictive on the types of deductions we can claim when we entertain business associates. As a result, when we go on business trips or attend conventions, we must be careful to separate business expenses from food, entertainment and beverage expenses. Legitimate business expenses are still fully tax deductible. However, we are only allowed to claim 80% of our food, entertainment and beverage expenses when we file our tax returns. As a result, airline, train, bus, and auto expenses are still fully tax deductible, as are hotel bills, cabs, etc., but not meals, booze and a night out on the town.

This can be a problem at a convention. If you pay one fee that covers everything except out-of-pocket expenses you may not be able to claim the entire amount as a tax deduction. In fact, based on Revenue Canada comments, it looks like you will have to segregate $50 per day from your total bill and treat it as an entertainment expense. If there are no meals and no entertainment provided as part of the package you will have no problem with this calculation.

43

Make a Night Out Tax Deductible

Boy, the cost of living keeps right on rising, doesn't it? In fact, it's almost too expensive to eat at home.

However, if you're a businessperson, even if it's a small business that you run on the side, you get to write off all the expenses you incur to develop your business, even if it's down the road. So, why not time your business appointments with your stomach's demands? That way you'll eat at the same time as your business associate does — and the bill will be at least 80% tax deductible.

In fact, for salespeople or others who are compensated for their sales expenses, this is an even better deal. Revenue Canada demands only that the expenses be related to the development of future business — and that's usually easy to substantiate if you aren't cheating. All you have to do, then, is plan properly.

Here's who can really win, though. You have a landscaping talent so you start a business of your own using your garage or basement while you still work for somebody else full time. Occasionally you take somebody out for lunch or supper (it might even be a neighbor who you're trying to sell on your services). The bill now becomes tax deductible against the profits you're earning in this little business venture.

But what if you aren't profitable — which can easily happen with a young company. Well, in that case you get to carry your nonincorporated business losses ahead as a tax deduction against your other forms of income even though they aren't related to your landscaping business. Revenue Canada has long felt that this rule was an easy one to abuse. Businesspeople might claim a luncheon or supper as a business deduction even though it wasn't entirely business related. As a result, the rules have been altered

slightly under tax reform. Now we can claim only 80% of meals, drinks and entertainment as a business expense. But even then, 80% is better than nothing. It still pays to arrange your affairs in the manner suggested above.

44

Travel Free and Get a Tax Deduction

When you travel on business, you incur some travel expenses. If you're self-employed, it's understandable that they will be tax deductible. But, when you are employed by somebody else, you should expect that person or company to reimburse you. When they do, you should be able to treat the funds as a tax-free reimbursement of business expenses. And why not? After all, that's all they were — your employer simply gave you back the expenses you incurred.

But what if your boss isn't generous enough to pick up the full tab even though you think it's justified? In that case you should claim that you haven't received a reasonable allowance to cover your out-of-pocket expenses. There's a good chance that you'll be able to add the expenses received to your income and claim them as taxable income. Then you'll be able to write off the expenses that you incurred as a tax deduction. The income received is offset by the expenses paid out so you don't pay tax on that amount — and the excess is claimable as a tax deduction against your income which should save you some tax dollars when you file your tax return.

Yes, it's better to have all your expenses picked up by the taxman. If that's not possible, any tax relief you can get is beneficial.

This tactic is generally available to sales types or to those who act as sales managers who are normally responsible for negotiating sales contracts. Those in different job classifications should seek professional advice to see if they qualify.

45

Donate Antiques to Your Favorite Charity

Tax reform has also affected the tax relief we receive when we share with the less fortunate. Those in the lower-income brackets actually benefit while those in the higher brackets don't receive as much tax relief. However, most of us may be able to manufacture more tax relief than normal by giving not money but something else.

Most of us give money from time to time to our favorite charity, but now that the tax rules have changed it might well be worth our while to give articles away that have appreciated in value. For example, if you have an antique that you purchased years ago at a low price, you could give it to your favorite charity at its present value.

You will have to give some thought to taxes, though, in that we're only allowed to earn $100,000 in tax-free capital gains in our lifetime. If you don't think you'll reach that point, you can get some extra tax relief without spending any money when you use this idea. If you think you will exceed $100,000 in your lifetime, you'll probably want to hang onto your antiques and give money or a life insurance policy to your church or favorite charity. See Tip 46.

If you purchased or inherited an antique years ago it's undoubtedly increased in value over the years. If you now donate it to your favorite charity you can claim a tax deduction for today's value even though it was worth much less when you actually received it. The increased value can be a tax-free capital gain, and any value above $250 will manufacture tax relief at the maximum tax rate regardless of your tax bracket. That's also a major change this year in that the first $250 worth of tax relief

is at 17% plus the percentage levied by your province. Beyond that you save 29% federal tax plus the provincial levy, regardless of how much money you earn. As a result, this tax tactic is as valuable to lower-income taxpayers as it is to those in the upper brackets.

It Can Make a Difference When Claiming Charitable Contributions

In the past we recommended that charitable contributions be claimed in the name of the higher-income spouse. That way the husband and wife would be able to claim the maximum tax relief regardless of which spouse made the contribution.

Under tax reform, though, we are going to change our attack. First off, it no longer really matters which spouse claims the tax deduction as we all now get the same tax relief. It's calculated as 17% of the first $250 contributed and 29% of the remainder. Those percentages, of course, are federal numbers. The provincial tax savings are added on top.

When I say it doesn't really make much difference who claims these deductions it's based on the fact that either spouse will create the same tax relief for the family. However, there are several other considerations. For example, taxpayers can claim no more than 20% of their net income in any year when claiming charitable contributions. If one spouse has a very low net income it may be easier to claim the charitable contributions in the other spouse's name. It seldom pays, though, to split them between spouses. You see, the sooner you exceed $250 the sooner you get to claim the 29% tax rate rather than only 17%. As a result, it's mostly a matter of deciding which spouse can claim the total amount of the charitable contribution.

There can be personal reasons for making this choice though. It may be more advantageous if one spouse is, say, in the public eye, to have that spouse make the contributions and claim them as well.

It may also be advantageous for taxpayers to consider making charitable contributions in their children's names — especially when they attend postsecondary school. While a dependant's net income determines whether or not they can be claimed as a dependant tax credit, it's their taxable income that lets us transfer deductions from their names to ours. For example, if a student attending postsecondary school has no taxable income, he or she can transfer any unused tuition and full-time education deductions to a parent, spouse, or other supporting individual. In this case it may well pay for a parent or spouse to claim charitable deductions in the student's name so other deductions can be transferred to a higher-taxed individual's name.

47

Get Paid to Volunteer

Not everybody has the money to give to charities. People might like to, but they have enough trouble getting along on what they have coming in as it is. They might, though, be able to give their time and services to a charitable organization.

If you donate time, you normally cannot get a tax deduction. Revenue Canada feels that your time is worthless until you get paid for it. If you give it away, you're falling right into their hands — you get no tax deduction.

If you are a printer or manufacturer, you have a better chance in that you can, at least, recover your costs as a tax-deductible donation. In point of fact, though, there are occasions where charities have given receipts for work done on their behalf even though no money actually changed hands.

And many charities seem open to the following: if you incur expenses while doing volunteer work, try submitting those expenses to the charity. We're talking about gas, oil, parking, telephone calls, stationery, stamps, etc. They may not be open to outright paying for them, as you hope they will, but they may be prepared to issue a tax slip showing that you donated an equivalent amount of money to that charity.

At least you'll get back part of your money from the taxman.

This year, this tax tactic is more valuable than in the past. Remember, once we exceed $250 in charitable deductions we enjoy tax relief at the lofty rates used by those in the highest tax brackets. If you exceed $250 you will get back close to half of your out-of-pocket expenses. It means those with the time can more easily justify giving their time to worthwhile causes.

48

Use Political Donations Properly

While tax reform has dramatically changed the way we claim many of our tax deductions, it has not changed the way we benefit when we contribute to the political party of our choice. In fact, when you look closely you can see that many of the new tax calculations have been altered so they mimic the tax strategies we use when we claim political tax credits.

Even though majority governments mean that we only have elections every four or five years, political parties are always out to raise money. Their task has been made somewhat easier in recent years as we now qualify for substantial tax rebates when we contribute to our favorite political party. And I mean tax rebates, not just tax deductions. The advantage to tax rebates is that they mean just as much, maybe more, to the mid- and lower-income brackets as they do to those at the high-income levels.

For example, no matter how much income you earn or how much tax you pay, you'll get a tax rebate or reduction of $75 when you donate $100 to your favorite federal party. The next $450 that you contribute qualifies for a 50% tax break with any additional contributions worth $33^{1}/_{3}$ cents on the dollar until you reach a maximum tax credit of $500. Realizing this, it becomes fairly obvious how we can save a few extra tax dollars when we contribute money to a federal political party. If the husband gives $200 while the wife gives nothing, the family saves $125 in tax. However, if the husband gives $100 while the wife also gives $100, the family would save $150 in taxes, $25 more. Obviously, then, it pays to split political contributions between spouses. You'll save extra taxes.

49

Give Your Life Insurance Away

Lots of Canadians would like to give money to their church or favorite charity, but don't feel they can go as far as they wish. They just don't have the resources. Retirement time is coming soon and they're trying to amass as much money as they can as they know they'll have to supplement their pension income.

Life insurance may be the answer — not buying it, but giving away an existing policy. Most of us buy life insurance when we are young to provide protection for our families while we amass enough resources to take care of them. However, once we've paid for our houses and educated our children we don't need life insurance as much, expecially when our health is reasonably good.

But rather than cancel the policy, maybe we could use it to get some tax relief. If the policy is a cash-value-type policy — that is, something other than term insurance — you could give the built-up value to your church or charity. The total built-up value would be tax deductible as a charitable donation which would save you tax dollars, probably when your tax bracket is at its highest. The saved taxes would then be available to help supplement your pension income when you retire.

Your policy may have a paid-up value which would mean you didn't have to make any further payments. However, if you did continue to pay monthly or yearly payments after giving this policy away, you'd be able to claim them as tax deductions as they'd also be helping out a charity or a church.

The charity or church won't be as disposed to this action as it would be to cash, but when you die and the organization gets a substantial sum of money it will be quite thankful.

When it comes to making this decision, don't forget about your

family. If they're going to need the money for funeral bills and the like, make sure they come first.

Those in the higher tax brackets always found giving money or assets to charities more advantageous than did those in the lower brackets. The tax relief was always better. Under tax reform though the advantages are almost reversed.

From now on the tax relief on the first $250 is a tax reduction of 17% plus the additional provincial increase. As a result, everybody is treated the same. That suggests that lower-income taxpayers will get more tax advantage when they contribute than higher-income taxpayers did. Once you exceed $250, though, lower-income individuals do even better than higher-income earners. Regardless of your income, anybody who contributes more than $250 gets tax relief at the highest possible marginal rate regardless of their tax rate.

To narrow this down to the easiest understandable quotient here's what to do. Everybody should contribute to the charity of their choice. Those in the lower brackets get an extra bonus. Everybody gets the maximum tax deduction once they contribute more than $250. As a result, higher-income types should continue to contribute as they pay a small price in the way of a lower deduction on the first $250. Those in the lower brackets should escalate their contributions as they get much more tax relief than normal.

However, when it comes to choosing between an RRSP and a charitable contribution it pays to pick the former. You get tax relief plus you keep your money and it compounds for a lifetime.

Can't Afford a Home? This Way You Might Be Able To

While it's the great Canadian dream to own a house, it's not always possible because of the cost associated with owning property.

Oh, if we could only enjoy the advantages of being a home-owner in the United States. Americans can write off all their mortgage interest, plus in many cases the interest they pay on appliance and other purchase loans. Well, we might be able to as well.

Picture a new condo development in your municipality. If you buy a unit on the tenth floor for your own use, you get no tax relief. However, if you buy a unit and rent it out you can write off all of your expenses, including interest, taxes, maintenance, utilities, insurance and more. So, why not buy on the eleventh floor and rent it to somebody — and talk that person into buying the tenth-floor unit and renting it to you. You each get the unit you want and you each get a raft of tax relief because you own rental property.

While it sounds simple, it isn't quite. You will have to pay rent to the owner of your condo and you will have to collect rent from the renter of yours. But that shouldn't really pose a problem. And maintenance won't be a headache either as you're in the same building paying the same maintenance fees, plus you'll be able to keep an eye on each other's properties.

Five years, 10 years, who knows how long down the road, all you have to do is sell these properties to each other. You've enjoyed the tax advantages, and now you get to sell (and own) without paying any capital gains taxes.

51

When You Own Mortgages or Annuities, Don't Pay Extra Tax

I have a definite preference for investments other than those that are simply interest bearing. Interest is taxable, whereas dividends from Canadian investments qualify for the dividend tax credit, and capital gains are tax free to a maximum of $100,000 in a lifetime (farms and small business $500,000).

In addition, some Canadians get lulled into paying more tax on some interest-bearing investments than need be.

When you lend somebody money through a mortgage, you normally amortize the loan over a long period of time. Using an amortization schedule, the borrower will pay the loan off in a series of equal monthly payments that are part interest and part principal. The interest portion is, indeed, taxable in your name, now that the $1,000 tax-free interest deduction has been cancelled. But, even before this tax change, the interest portion could have been taxable for many mortgage lenders. You see, if you lent money to a family member or a business associate it never qualified for the $1,000 tax-free deduction. And once you exceeded $1,000 the remainder was always taxable. But, *the principal portion of these payments is tax free*. After all, it's simply the return of your own money, so why should you pay any tax on it?

Make sure you get an amortization schedule that shows how much of the income you earn from a mortgage is taxable and how much isn't. That way you won't pay any more tax than is necessary.

A similar case exists when you have an annuity purchased with non-tax-sheltered cash. If you used funds inside your RRSP to purchase an annuity, all the income you earn is taxable. If you

used Income Averaging Annuity Contracts to save taxes several years ago, the income you earn from these investments is totally taxable as well. However, if you used savings to purchase an annuity as a pension, you should pay tax on the interest only.

Crisscrossing a Mortgage Can Save Taxes

If you sell your house and are forced to take back a mortgage, you are in for a tax problem. However, there can be a way around it. While you only granted this loan to help sell your house, Revenue Canada still treats the interest you receive as taxable income. But what if you didn't grant the purchaser a loan in the normal manner? What if you went to a banker and borrowed the money to lend to the purchaser of your home? The interest you pay on that loan will be tax deductible because it's an investment loan. That interest will offset the interest you earn on the money you lent to the purchaser of your house.

Revenue Canada demands two things to make interest tax deductible. Number one, the investment must produce a regular income. The purchaser of your house will, of course, make regular payments with part of the interest. There's your regular rate of return. Under number two, the investment must show some possibility of producing a profit. That's a little harder to prove in this case. However, when interest rates fall your vendor-take-back loan will be more salable. If rates fall far enough, you might even sell it at a profit. There's one example of a potential profit.

If you borrow the money you're going to lend to this person on a variable-rate loan or a demand loan and interest rates fall, the cost of your money will fall while the rate of return you're earning will remain constant. If rates fall far enough you might, in fact, pay less than you earn. That's another chance at a profit.

53

Renegotiating Your Loan

Can you imagine any time when we had a better opportunity to make or save money than right now? Interest rates have risen and millions of borrowers are throwing their hands in the air and accepting the higher rates, even though they don't have to. *There is no obligation to automatically accept the recent interest rate increases.*

If none of your loans have come due for renewal you haven't had to worry about any of the recent interest rate increases. However, maybe you don't realize that you've been affected. Maybe you have demand-type loans, the type that investors and businesspeople use. The interest rate on these loans changes every time the prime lending rate is adjusted. Or, maybe you borrowed money using a loan where the interest rate was high because you had little collateral. Now you have lots to offer a lender.

Borrowers in these situations should take a close look at their loans as they may not have to pay today's higher interest rates. In fact, they may be able to negotiate a lower interest rate than they are presently paying.

Why? Well, interest rates are based on the general market scenario and the credibility of the borrower. If you borrowed when you were in a poor negotiating position you may be able to cut a better deal right now. Or, if you have a high rate loan coming due right now you may be in position to renew it at a better rate than you presently pay.

In addition, if you believe that interest rates are close to peaking and will fall in coming years, you may want to negotiate your way out of fixed-term loans into variable-rate loans where your rates will fall with the bank rate and prime lending rate. Many people borrow money to buy cars, appliances, furniture, etc.

using consumer loans. In fact, many consumers buy these goods on their credit card limits, where interest rates are far higher than anywhere else in the industry. The rate charged on a personal loan is often lower than that charged on a consumer loan and generally far lower than you pay on a credit card balance.

Recognizing this, what better time to renegotiate than right now?

Many people remember the stock market massacre of October 1987. However, since then stock and mutual fund values have risen substantially. And real estate prices appear to have not even been affected by the stock market selloff. If you lodged any form of collateral to borrow money in the last year or so you might be able to argue with your lender that it's worth substantially more right now than it was when you struck your deal. If so, you should be able to justify that you are a better risk and, as a result, that you should be able to borrow at a lower interest rate.

Maybe you agreed to pay prime plus 2% when you originally borrowed. Now your credit rating has improved substantially, so you can negotiate a better interest rate. It might be that your income has risen substantially. Or maybe the value of the collateral you lodged as security has appreciated in value or maybe you've paid down your loan by a substantial amount. If you are involved in any of these situations you might be in position to lower your interest rate by enough to offset the recent interest rate increases.

Yet, few Canadians will take the time to renegotiate with their lenders no matter how much the situations change.

You see, lenders lend money on the best terms they can arrange. Once the loan is in place, at the terms arranged, there is no obligation on their part to voluntarily change the rate on your loans. However, it's a different story if you request a review. But it's up to you.

What if only one spouse worked when the loans were arranged but now there are two working spouses? The family income has risen, so you are a better risk. Rather than simply using part or all of the second income to pay down your loans, why not also

go to your banker and try for a lower interest rate? The family income is higher and the loans will be paid down faster so you pose less risk. Maybe you now fit the lender's formula better and can arrange for one lower rate first mortgage to replace the existing first and second mortgages.

Higher interest rates are not a problem for those whose loans are not coming due for renewal. But, maybe you could actually lower your loan rates by negotiating with your lender. And, if you do have a loan that is coming due for renewal or you are about to take out one at today's rates, maybe you can negotiate a better deal simply by presenting a better case.

54

Save on Taxes When Selling Your House

Canadians are big movers. In fact, we move on average every three years. Some never move so that distorts the averages a bit. However, most of us do move several times in our lifetimes.

When you do it might be an opportunity to save some taxes. You see, property law says that a family's principal residence is jointly owned by both spouses. That means that the proceeds from a house sale can be split evenly between both spouses. It also means that each spouse would be able to invest their half of the proceeds to earn investment income that's taxed at a lower rate, if, in fact, it's taxed at all.

The problem, though, is that many of the people who sell a house plan to move into another one. That means that they'll want the money to help pay for the new house. However, in some cases they may have other investments built up in the higher-income spouse's name. If so, they should consider selling them to help pay for the new house and letting the lower-income spouse keep his or her share of the proceeds from the original sale. Effectively, they've been able to transfer money for investment from a higher-income spouse to one who will be able to invest it with a lower tax liability.

For some families this type of transaction happens regularly. Their house rises in value at the same time as they pay off their mortgage. They sell the house and move into a similarly priced one. The proceeds are split.

It's especially useful for those who are downsizing or retiring. Splitting the income means less tax on the income.

To show you how well this can work take a look at these numbers. If both spouses worked there's no question that you

can justify an equal split of all the proceeds from a house sale. Let's assume that you sell a $200,000 house. Rather than leaving all the money in one spouse's name, you should split it — $100,000 to the husband and the other $100,000 to the wife.

But, what if you want to buy another house? In this example the husband, who is the higher-income earner, should use his $100,000 to buy a house. As a result, the wife can invest her monies without any fear of the income being taxed in her husband's name.

Maybe you aren't ready to downsize. As a result, a $100,000 house wouldn't satisfy you. In that case it would pay for the husband to take on a mortgage or better yet, sell some investments so that he could buy the house mortgage free.

Ah ha, but maybe you like the investments you own. Well, don't worry. You don't have to get rid of them. Simply sell them to your spouse. Now you as a family still own them. Besides, your spouse was going to have to invest the money somewhere, right? It might as well be in something you like.

And, if you want to buy some investments you have $200,000 (in this example) of paid-up equity in your house. If you borrow against it you have a tax-deductible investment loan.

If only one of you worked, it can be argued that only the worker contributed to the house. In that case a divorce would still give your spouse one half of the equity. So, why shouldn't it work if you aren't getting a divorce? In the worst case scenario you should have no trouble justifying transferring one half of all the appreciation over and above the original purchase price to your spouse.

55

When You Sell Your House, Try Not to Take a Vendor-Take-Back Loan

When it's tough to find a buyer for your house, especially when interest rates are high, it's not uncommon for homeowners to offer low-rate financing to attract a buyer. This practice is called vendor-assisted financing or a vendor-take-back mortgage. As a vendor, avoid it whenever possible, as you can end up in a major tax jackpot.

Here's what happens. When you lend somebody money you earn interest. Interest used to be tax free until we exceeded $1,000, but that's no longer possible as a result of tax reform. The income received on a vendor-take-back loan is taxable and must be claimed. As a result, you've offered a lower-than-normal rate of interest in the first place and get to keep even less of it after you've paid your tax bill.

You'd be better off taking the money and investing it in stocks, mutual funds or rental real estate where you can earn a higher rate of return. And what if you're planning to buy another house? If you don't get all cash for your house, you'll have to take on a larger-than-normal mortgage when you buy your new one. The interest you earn on your VTB will be taxable but the interest you pay on your new mortgage will not be tax deductible as it isn't a business or investment loan.

You'll end up paying twice as much on your new loan as you earn on the one granted to the purchaser of your property. So, try to avoid vendor-assisted financing when you're the vendor.

56

Drop a Vendor-Take-Back Mortgage when the Rates Fall

It's not uncommon for a vendor to offer a take-back mortgage to the purchaser of his house, especially when interest rates are high. It makes it easier for the vendor to sell his house because the terms of a VTB mortgage are usually more attractive than a lender's would be. The problem, though, is that the vendor normally faces a tax problem when this is done. The interest received on the mortgage loan is taxable now that the $1,000 tax-free investment income deduction has been cancelled. At the same time, if the vendor has been forced to take on a second mortgage or a larger loan when purchasing another house, the interest paid on that loan won't be tax deductible as it was taken to buy a principal residence and not an investment or business.

When interest rates fall, though, two things can happen. Number one, the borrower may be happy to get out of the VTB. Maybe he or she can now combine the VTB and the normal first mortgage into one mortgage at today's new lower interest rates. Or maybe the borrower has the cash to outright pay it off.

The second possibility is that the vendor might be able to sell the VTB mortgage on the open market. If interest rates fall far enough, the loan may now be higher than the going interest rates at commercial lenders. When that happens, investors may be prepared to buy it from the vendor at the full face value. Normally when the interest rate of a mortgage doesn't match existing interest rates, an investor will offer a discounted price, i.e., something lower than the face value. However, when interest rates are low, the vendor has a better chance of getting all his money back. Then that money can be used to pay down a mortgage. Taxes are saved plus the mortgage payments become tax deductible.

57

Buy a House for a Student

For many parents it's pay-up time when their children head for college or university. They don't have enough money to pay for tuition, books *and* room and board when they attend school away from home. As a result, the parents often have to help pay their rent and other expenses.

But what if they turned the tables and purchased a house in a college town and rented it to their children and other students? Although a good idea, in the past it wasn't implemented much because the parent could eventually be taxed. Any increase in value in the property was taxable as a capital gain. Now, though, we don't have to pay capital gains on most of the increase (depending on our tax situation). A good idea is now even better.

If a parent has to pay for a student's lodging anyway, and if he or she has the money, why not buy the property rather than renting it? Because it's an investment property, the interest the parent will pay on the mortgage or mortgages will be tax deductible. In addition, the property taxes, insurance, maintenance, utilities, etc. will be tax deductible. As a result, most or all of the costs will qualify as tax relief. In addition, the child should be able to attract a number of other students as potential renters. That income will be offset by the tax deductions making it tax free.

The child should be charged the going rate for rent so as not to create any problems with Revenue Canada. However, the parent will need a building manager. Who better than the child? Pay him or her the same salary as you would pay a manager. It's tax deductible to you. The child uses it to pay for his or her education. Indirectly, the education costs are tax deductible.

58

A Retirement Home Can Be Tax Deductible

Many Canadians like to spend the winters in a warm climate when they retire. The problem, though, is that they don't plan ahead. They wait until they actually retire to buy or start to rent. Then they pay the going price — and they do it all themselves. Had they done a little planning in advance they may have been able to lock in to prices that were in vogue many years earlier, they may have been able to generate some tax deductions, and they may have been able to get somebody to pay for their retirement home.

Rather than thinking of purchasing a house in Florida just before you retire, think of buying it as a rental property. When you buy a rental property the interest and other expenses are normally tax deductible. The same applies to a rental home in Florida or Hawaii or wherever you plan to retire. In addition, you'll be able to rent the property out until the time you choose to retire. That rental income, while taxable, will end up tax free when the expenses incurred while owning the property are used to offset it.

If the losses exceed the income, the remainder can be used as a deduction against your other income. In that case the taxman pays for part of the cost of your retirement home. When the income exceeds the expenses, the renters are paying for the property. Either way you've locked in today's prices rather than waiting and either the taxman or the tenants have picked up much of the cost.

When it's time to move in you do so, but at a fraction of the cost you'd pay had you waited.

59

We Can Make Our Mortgages
Tax Deductible If We Want

Most Canadians pay their mortgage payments with tax-paid dollars. That is, they work all day to earn enough to pay their monthly mortgage payments. However, they forget that the taxman takes a portion of their salary before they get it. That means that we pay our mortgages with "after-tax" dollars. There is a way, though, to make our mortgages tax deductible — and as a result, get the taxman to pick up part of the cost.

If you have a mortgage and also have investment income, you may be in double jeopardy. That is, your investment income is taxable at the same time as your mortgage interest isn't tax deductible. If so, you should consider selling your investments to pay off your mortgage.

Once you do so, though, you may all of a sudden wish you had some money to invest. But, you do. You have a house with a small, or no, mortgage, so why not take advantage of the built-up equity to arrange a new loan to buy investments? When you do that the loan will be classed as an investment loan and the interest will be tax deductible. Don't think that you have to wait until you've paid off your mortgage, though. In fact, the individual with a $50,000 mortgage who also has $5,000 in savings or investments has the makings of a tax-deductible mortgage.

This individual should consider cashing in the $5,000 worth of investments and using the proceeds to pay down the mortgage. Then he or she can take a $5,000 personal loan, a second mortgage or increase the first mortgage back up to $50,000. If the $5,000 is then invested, that portion of your loan is now tax deductible. In this example, $5,000 of your $50,000 mortgage or 10% of it is tax deductible.

All you have to do then is calculate the interest portion of your mortgage payments and claim 10% as a tax deduction when you complete your tax return.

In coming years you can repeat the process to make even more of your mortgage tax deductible.

60

Another Way to Make Your Mortgage Tax Deductible

Who says we have to pay the high cost of mortgages and who says we can't afford to buy a house because prices are rising too quickly? Well, it certainly isn't me, because I believe we can get the taxman to help us do both — and we can get somebody else to pay much of the cost of the house.

Sound impossible? It isn't. It might not work for everybody, but for many, using these theories would wipe out much of the pain of mortgage rates and the inability to afford a house.

Under existing legislation most personal mortgages are not tax deductible. As a result, we pay a much higher real interest rate than we realize. In fact, the average taxpayer (in the 35% tax bracket) has to pay a real rate of 17% when he or she has an 11% mortgage. Because the payments are not tax deductible, we have to earn the equivalent of 17% to be left with 11% after our employer remits tax to Ottawa and the provincial governments.

But if we could make our mortgages tax deductible we could make it a lot easier to own a home. And, if we could get somebody else to pick up part of the cost of ownership we could make it a lot easier, and, Revenue Canada is quite prepared to help us with both ideas.

To make the interest we pay on our mortgages tax deductible, all we have to do is convince Revenue Canada that we borrowed the money to make money. They're quite prepared to be our partners if they think they'll share in a windfall down the road.

Recognizing that, we might be wise to buy a duplex or triplex that we rent out, even if we choose to live in part of it. For example, if we purchased a triplex and lived in one unit we would be justified in claiming two thirds of our interest expense as a

100

tax deduction. The other third would be a personal expense, but our real mortgage cost has now fallen substantially.

But, there's more. The rents earned on the other two units will offset most of the other expenses related to owning this real estate. That is, the renters will help to carry the cost of owning your property at the same time as the taxman helps with the mortgage. In addition, when we own rental property, we are allowed to claim the heat, hydro, property taxes and other legitimate expenses as tax deductions. If we want to advertise for tenants, incur legal bills to get rid of them or to collect the rents, we again will get some tax relief.

You see, if you feel you can't afford to buy a house right now, why not consider buying a multiple unit property so you get some tax relief and somebody else to help with the bills?

So far it doesn't sound too bad. But, before you start calling real estate agents don't forget that you will be giving up some privacy, you will have to do or arrange to have somebody take care of the maintenance and you will have to accept the fact that while a principal residence will rise in value completely free of tax, a rental unit does not.

Ah, but even when we sell this property we get a break. You see, even though the federal government has gone back on its word and reduced our tax-free capital gains limit from $500,000 to only $100,000, we still come out a winner. If we decide sometime in the future to remove the tenants and convert the property to a single family residence we may not have to pay any tax after all, even though Revenue Canada considers this the equivalent to outright selling the property. In the first place, one-third of the gain will be tax free as the property was used as our principal residence. The remainder of the gain will qualify for the $100,000 tax-free capital gains deduction, and, if the property were jointly owned by both spouses the first $200,000 in gains will be tax free. That should eliminate most, if not all, of your tax bills.

If, instead of renovating, you choose to sell the property, the same theory applies. However, a rental property in a good area

will generally attract a larger audience and price than will a single family home. Now you'll be able to take the proceeds and buy your dream house. The advantages have been substantial. To begin with, you've been able to buy at today's prices. As a result, any future increases are in your favor rather than against you. You've enjoyed some tax relief, somebody else has picked up part of the cost of ownership, and any increase in price has been tax free. What more could you ask for?

61

Don't Mortgage Your Property Taxes

Many homeowners have no choice. When they buy a house, the lending institution demands that they include in their mortgage payment enough money to service not just their interest and principal but also their property taxes.

While that's not a bad idea if you think you'll have problems paying your tax bills on time, it is a bad idea financially speaking. You see, when you make all your monthly payments on time you will generally have more money in your tax account than you need. It might be nice to have that cache sitting there to protect you when tax rates rise, but it's also just as easy to increase your mortgage payment.

In many cases, you see, your mortgage anniversary or renewal date will coincide with a tax adjustment. As a result, you normally don't need to build up a balance in your tax account. All you have to do is budget for a slight increase.

The real drawback, of course, is that while this money is sitting on deposit at the financial institution, it's earning a very low rate of return, if, in fact, the lender pays you any interest at all. Instead, the extra balance could be paid against your outstanding principal which would pay it off faster than normal. And, what's worse, when you fall behind in your tax account the lender adds the shortfall to your loan. That can mean that you end up paying interest on that amount for the rest of the life of the mortgage.

It's a two-sided street when you add your property taxes to your mortgage payment. If you feel you'll keep abreast of your tax requirements you should try to pay them separately. If you fear you'll fall behind, pay them together. If you choose that route try not to keep too much cash tied up in your tax account —

and whatever you do don't fall behind. If you fall behind, you may pay interest on the amount along with the rest of your loan for the rest of the life of the mortgage.

Once you've paid off your mortgage and decide to remortgage to buy investments, you seldom have this problem.

When You Move, Do It Right

While most Canadians try to time their move so it takes place in the summer months when the weather is good and the children are out of school, not everybody is able to do it at that time. As a result, there's hardly a day that goes by when somebody isn't incurring the expense of moving. Part of that expense, though, may be able to be passed on to somebody else — an employer or the taxman.

People move for many reasons. A job transfer may take them to another part of the country. Another child can produce the need for another bedroom or conversely, the aging of a family can produce the desire to move to a smaller dwelling. Aging often creates the need to move. As we age we want a place of our own — and as we get even older we often can no longer handle the maintenance that accompanies ownership of a residence. As a result, we move into a condo or a rental unit. And, finally, we have marriage. When we get married we move into a dwelling with our spouse — or if we divorce, we move into one of our own.

While it's apparent that there are many reasons to move, not everybody is fortunate enough to get help with the cost. If you decide to make a move with no urging from your employer you have little hope for tax relief or aid from your employer. And, if you move only a short distance you likewise have little hope for tax relief.

If your employer is moving you to a new location it's up to you to negotiate some moving expenses. And it's well worth your while. You see, any expenses he or she reimburses you for will be fully tax deductible to the corporation but will be tax free to you. The boss probably isn't too interested in adding your expenses

to your salary but you can still benefit. If you ask him or her to waive an equivalent amount of salary, he or she will be paying the same number of dollars as usual and getting the same tax relief. It's one thing to get a tax deduction and save up to 47% of your expenses but it's a lot better to get 100% back from your employer.

By the way, when you're talking to your employer try to arrange for him or her to pay for things that may not be tax deductible on your return. Then many or most of the things that you actually pay for will be claimable as tax deductions when you file your return.

How do you make your moving expenses tax deductible? There are several requirements that must be met. The first is that you must make your move in connection with a job change, beginning a business or postsecondary school education. That means you might be able to claim some of your moving expenses if you move somewhere to start a business of your own. If you move to another city to take a new job or to assume a new position with the same employer you may also be able to claim some of the expenses you incur that are not reimbursed by your employer. However, it's not automatic. There's one other requirement that must be fulfilled.

You must also move so that your old place of residence is at least 40 kilometres farther away from your new job than is your new residence. Many people are of the mistaken impression that they only have to move 40 kilometres to make their moving expenses tax deductible. But that's wrong. In the first place you must combine the move with a job change and secondly you must meet the distance requirements.

When you move a long distance, say from Hamilton to Calgary, there's little question about meeting the 40 kilometre rule. However, when you move from one neighborhood to another or from one nearby city to another it's easy to eliminate that requirement.

As to the type of expenses you can claim — packing, transporting, insuring and storing your furniture naturally qualifies. But so does the cost of breaking a lease and disconnecting appli-

ances. If you own a house now *and* are buying another one in your new location, you can claim the costs incurred when you sell your existing house and the legal bills and land transfer taxes incurred when you buy your new one.

While your furniture is being packed and/or transported you can also claim up to 15 days temporary board and lodging at a combination of your existing location and your new one. You are also allowed to claim all your out-of-pocket costs as you transport your family and household to your new location. That includes airfare if necessary or gas and oil plus food and other expenses along the way.

Most often we think of these expenses when we are moving to another job. However, students also qualify for moving expenses. If they are moving home in the summer months to take a summer job they can claim their expenses against their summer income. If they are moving back to school they can claim their expenses against any taxable bursaries or scholarships they earned. (See Tip 63.)

And, don't forget that moving expenses still come before the net-income line, which helps you lower your net income at the same time as your taxable income. The net-income line is used to determine whether or not we can claim other tax deductions such as dependant deductions and the child tax credit.

63

Students Can Claim Tax-Deductible Moving Expenses

Very few parents take the time to talk to their children about their financial situations. They think that their children don't earn enough to pay tax, so they don't have to worry.

However, there is indeed an important tax-saving reason for these parents to look at their children's tax situations because they could save taxes for themselves, not their children.

Children are tax deductions provided they don't earn more than $2,500 in net income during the year. If your child has a part-time or summer job, that limit can easily be reached. That's why it's important that parents look at their children's incomes during the year. There are things like tuition, moving expenses, registered retirement savings plans, etc. that can help lower a student's net income so that the child once again is considered a dependant.

When children move home in the summer months, they can claim moving expenses if the move brings them at least 40 kilometres closer to their summer job than they would have been had they remained in their college town. Included as tax deductions are the moving costs themselves, or storage for their furniture, the transportation expenses to get home — including air, train, bus, gas and oil — plus living expenses and food along the way.

It might cost money to break the lease, insure the furniture, disconnect appliances, etc. so make sure you help your child compile every expense incurred. These tax savings will come back to you in most cases rather than helping your child save taxes. All the more reason for you to talk to your child or children about their financial circumstances at least once each year. The best time is the fall, but certainly by year's end.

64

Save Taxes by Picking the Right Month to Move

Many of us can't pick and choose a time to move because our employer tells us when to do it. Those who can, though, may be able to save some tax dollars by picking the right time of year.

The Canadian tax system has us pay our federal taxes first. Then we pay an additional portion of those taxes to the government in the province where we live on the final day of the year. What's even more important, though, is the realization that the percentage we pay this provincial government varies from province to province. It doesn't matter whether we live in the highest-taxed province most of the year; we'll pay the tax rate in the province where we reside on the last calendar day of the year.

Knowing this, we can wisely choose our proper course when we're planning a move late in the year.

Tax rates change from year to year, however, we can normally count on only small changes to the positioning of provinces in their order of taxability. We used to recommend that individuals move from the east, where taxes are higher, to the west, where they are lower, as the year end approached. With both federal and provincial tax reform changing the federal rates and provincial rates, this rule of thumb doesn't quite work any longer. However, it's relatively easy to track the provincial rates — which can help us decide to move from any province to another.

Following are the combined federal and provincial tax rates for each province and territory. Because we pay tax at the rate applied by the province where we live on December 31 of any year, it pays to move from a high-rated province before the year ends. Conversely, it pays to delay any move from a low-taxed

province to one where rates are higher until the beginning of a new year.

When looking at these numbers, consider that you are a taxpayer with $30,000 in taxable income. That is, you've used every tax deduction you can and you still have $30,000 on which to pay tax. The next dollar you earn will be taxed at the rates shown. However, don't get caught in the trap of thinking that these numbers are the maximum you can earn. The highest tax rates generally click in at around $55,000 in taxable income — with Ontario and P.E.I. initiating their highest rates above $85,000.

Quebec	46.99%
Manitoba	44.82
New Brunswick	42.38
Newfoundland	42.38
Saskatchewan	41.78
Nova Scotia	41.47
P.E.I.	41.34
B.C.	40.17
Ontario	40.04
Alberta	39.37
Yukon	38.48
N.W.T.	37.96

Using this theory, it would pay for a taxpayer who had some flexibility in timing to move from Quebec to the Yukon before the end of a year. Even though his or her employer has been withholding taxes at the higher rates levied in Quebec, the taxpayer would only have to pay tax on the full year's income at the lower rates levied in the Yukon (or any other province chosen). As a result, the taxpayer would be in for a sizable tax rebate.

And, just in case you don't think it means very much, a move of this nature would save the taxpayer more than $2,500.

Conversely, moving in the wrong direction (that is, from a low-taxed province to one where rates are high) would cost you additional taxes on all the income earned that year.

Granted, not everybody moves late in the year and not every-

body can dictate their moving date. But, where possible, you can save yourself a sizable chunk of tax dollars by doing a little research before you make your move. A good chat with your employer about the timing of your move may be all that's necessary. After all, your boss wants a happy employee. A little extra cash can be very helpful.

When You Move, It Doesn't Always Pay to Sell

Canadians regularly get transferred from one job to another. When we move, we normally sell our existing house and buy a new one in the city where we're relocating.

Sometimes, though, it can pay to hang onto the old house as well as buying the new house. Naturally, finances will play a role — but so does the taxman.

If you do have the resources to handle two properties and if you think there's any chance that you'll get transferred back to the city where you own house number one, you can profit from a special four-year provision. It allows you to claim two properties as your principal residence over that time period.

Actually, now that we have a capital gains tax holiday most people can own two or more houses without worrying about tax. One is legitmately classed as a tax-free principal residence. The other or others won't trigger capital gains until you sell them, and then most of the gains will be tax free under the capital gains tax holiday.

However, if you can use the special four-year principal residence rule, you'll come out even further ahead.

In either case here's what happens. If you move to a new residence it will be treated as your principal residence. As a result, it will rise in value totally tax free. In addition, any gains won't erode the $100,000 of capital gains that your're entitled to earn in a lifetime. Nor will they affect the minimum tax rules.

At the same time, if you were able to hang onto house number one, you could get some tax relief. If you rented it out to somebody else they'd cover most or all of the operating expenses. As a result, you wouldn't have to worry too much about carrying

costs. In addition, all the expenses you paid would be tax deduct-ible — first, against the rental income, and secondly, against other forms of income. As a result, any expenses not paid by the renters could end up as tax deductions on your tax return.

But real estate generally rises in value. That, of course, is one of the reasons why you'd use this idea — because you felt that house number one was going to jump in value in coming years. You knew you maintained it well and that it wouldn't create any problems. And you'd even like to live in it again sometime.

If this property does rise in value, you'll earn a tax-free capital gain on top of having the tenants pay most of the costs. That's not a bad deal.

By the way, when it comes to making this move it's best to leave maximum mortgage financing in place on house number one. As it's going to be a rental property, the interest on that mortgage will be tax deductible.

You also want to raise as much cash as possible for house number two. It's going to be your principal residence so the mortgage interest won't be tax deductible. As a result, you want as small a mortgage as possible.

If you use the four-year rule you get a bonus. The gain in value in both houses can be claimed as part of your principal residence. As a result, neither will affect your $100,000 tax-free capital gains. So don't always sell when you move.

Strategies For Your Fifties

The older we get the more cautious we should become when it comes to managing our money. We don't want to lose the assets we've accumulated to date but, by the same token, we don't want to let them stagnate to the point where they won't produce any future benefit. That's why it's probably more important for those in their 50s to get a handle on their financial requirements than anybody else. The young have plenty of time to make mistakes, although they will make substantial gains the sooner they start. Older individuals are terribly restricted in their options, so the sooner they start the better chance they have.

It's imperative that those in their 50s use as many tax deductions and tax deferrals as they can. That will give them more to work with. It's also important that they rid themselves of unnecessary expenses as quickly as possible so they have money to invest to produce future assets to generate retirement income. After all, they are 10 to 15 years away from retirement when their income levels will normally decline.

The very first consideration would be to do a budget check. Track your money for a month or two to see where it's going. Unless you know what you're doing with it you won't know whether you're making mistakes. The next step is to look hard and long at your tax situation. You can expect yearly salary increases between now and retirement, but will they be greater than the rate of inflation. Regardless, the more tax you can save in the next few years the more money you'll have to invest. When seeking out tax relief, though, you don't want to expose yourself to any more risk than is absolutely necessary.

That's why your company pension or registered retirement savings plan is so important at this stage. I say either as you may

want to choose one over the other or you may want to combine the use of these plans.

It's not unusual for a company pension plan to provide a lower yield than is available through a personal RRSP. However, if your employer matches your contribution you can already be 50% ahead of an RRSP. As a result, it's important to compare the yields in the proper context before making your decision.

There's something else you should consider, especially at this age group. It's important to start moving money out of the higher-income spouse's name into the lower-income spouse's so that both spouses will have income as you approach retirement. Rather than having all the money taxed in one spouse's name each spouse will qualify for tax deductions, and when income becomes taxable it will be taxed at a lower rate if it's split between two tax returns rather than all lumped onto one. The RRSP will play an important role in this discussion as we have a choice whether we contribute to our own RRSP or one in our spouse's name.

It's called a spousal RRSP. The higher-income spouse will receive the tax deductions when he or she contributes to it, but the lower-income spouse will eventually draw a pension from it that will be taxed at that spouse's lower rate. And don't forget the pension-income deduction. Each Canadian taxpayer who receives pension income other than that sponsored by a government can claim the equivalent to the first $1,000 as tax-free income. You know your spouse will eventually receive the Old Age Security Pension and as a result will be lost to you as a dependant deduction. As a result you might as well plan for that day and arrange to get personal pension monies into his or her name through the use of a spousal RRSP. The first $1,000 will be tax-free and the rest will be taxed at a lower rate than if it were earned in your own name.

If the lower-income spouse also has income or assets it's wise to consider letting that spouse keep all of his or her income and investments so they will produce income in coming years that will be taxed at a lower rate.

It's right about now that it becomes even more important to pay off your outstanding debts as quickly as possible. It's not as

big a problem when you have tax deductible loans for investment purposes that are producing tax deductions and a decent yield at the same time. However, when the loan isn't tax deductible it costs you as much as twice the quoted interest rate. As a result, paying down your mortgage faster than normal right about now is a must. Don't forget also that under tax reform we can no longer earn $1,000 in tax-free investment income each year. So there's not much use accumulating an emergency savings plan when you have an outstanding mortgage. The interest you earn (generally at a lower rate than your mortgage costs) will be taxable while the interest you pay on your mortgage will not be tax deductible. It's called double jeopardy. If you ever run into a situation where you need money you'll have bargaining power with your banker as your mortgage will be smaller.

This is also the perfect time to look ahead to retirement, not from a financial standpoint, but from a location consideration. It's not uncommon for people to sell their homes and move into a rental unit at that time. Personally, I don't care for it, especially under tax reform which makes all interest income taxable. I'd rather see people in this position sell their houses and move into a condo. They don't have the maintenance and they still own a principal residence that's going to rise in value tax free, in addition to the tax-free capital gains we're entitled to earn. A nice trick, though, would be to buy the condo now and rent it out until you're ready to use it. The carrying costs would be tax deductible, creating tax relief against your salary, the tenants would cover the cost of owning the property, and more importantly, when it came time to move into it you'd find that you were way ahead as you'd purchased it at this year's price — not the inflation-effected prices in vogue 15 years or so down the road.

If you're planning this attack you might want to purchase your retirement home in the warm southern climes or at the lake, where you'll really be able to put your feet up and enjoy the benefits of the financial planning you did when you were in your 50s, the most important time of your life.

No Money? You Can Still Have an RRSP

You have taxable income but you don't have any disposable cash. Does that mean that you can't take advantage of a registered retirement savings plan this year? The answer is no, you don't have to give up on tax relief. There's something called a "no money RRSP" that could solve your problem. And then, of course, you have the ability to borrow the money for your RRSP contribution. And, yes, I know that the interest on money borrowed for RRSP contributions is generally not tax deductible. However, there is a way to make it tax deductible. And even if it isn't, maybe it's still worthwhile borrowing to contribute anyway.

If you have the money it's pretty easy to decide whether or not to contribute to an RRSP. If you pay taxes you generally should, if you don't there's not much need for one of these plans as a tax-saving device.

If you don't have the cash, though, your decision is much more difficult.

As to the question of borrowing to contribute to an RRSP, I find that it is almost always worthwhile. Sure, if you have the cash you should use it, but if you don't, give some thought to this scenario. If you borrow $5,000 to contribute to an RRSP and are in the 40% tax bracket you'll get a $2,000 tax rebate. If you pay it against your loan you'll only have $3,000 outstanding. And, if you gradually pay the loan down as the year progresses you'll probably pay between $200 and $250 in total interest. Yet, inside your RRSP you'll have the full $5,000 earning investment income. As a result, you should earn between $500 and $750. That's a lot better than the interest you just paid.

In addition, don't forget that you only have to repay $3,000

of the $5,000 you borrowed. So, yes, it generally pays to borrow for RRSP contributions if you don't have the cash.

The drawback, of course, is that even though you're going to invest the money, the interest is not tax deductible. However, there may also be a way around that problem. Let's say you want to contribute $5,000 to your RRSP. You don't have the cash but you do have some existing investments that you could cash. If you did, you could contribute the cash to your RRSP and create tax relief. Then you could borrow $5,000 to buy similar investments. This is now an investment loan so the interest is tax deductible. In effect, you've borrowed for your RRSP contribution but by combining it with an investment loan you have made your interest cost tax deductible.

The key, in any case, is to pay the loan off as quickly as possible, as you undoubtedly will want to contribute again next year. If you borrow every year you will build up loans that require servicing. Some taxpayers find this an acceptable practice. They have tax-free income being generated inside their RRSPs while they have, in some cases, tax-deductible loans outside. The tax relief is greater and the tax-free pool of money growing inside the RRSP is greater.

Those who have no money but who happen to own existing investments have another option. If the investments meet certain criteria they can be transferred into an RRSP. The first step is to open a self-directed RRSP through a financial institution that offers one, a stockbroker or a financial planner. This type of RRSP is allowed to hold investments such as term deposits and guaranteed investment certificates, mutual funds and stocks, bonds, debentures and mortgages — provided they are basically Canadian oriented. If you happen to own some Canada Savings Bonds, term deposits or mutual funds that you don't want to sell, you could consider transferring them into your self-directed RRSP. That way you get the same tax relief as if you'd contributed cash without having to actually do it.

When deciding to contribute existing investments you must make the proper calculations. For example, contributing $4,000

worth of Canada Savings Bonds may be acceptable. However, if there's accumulated interest attached to those bonds you'll have to consider the fact that you cashed the bonds before contributing them. That interest will be taxable. It's better to cash only enough principal and interest to reach the $4,000 level. The same theory applies to stocks or mutual funds. There may be accumulated capital gains. In this case, though, you have an advantage. As capital gains are presently tax free to $100,000 you won't have to pay any tax on any gains created in this way. In fact, this idea has gained great appeal right now. Investors who have gains, but expect more, are transferring stocks and mutual funds into their RRSPS to purposely create tax-free capital gains while still holding onto their investments where they'll appreciate further inside their plans.

So, you see, you don't actually need cash to create tax relief.

68

Your RRSP: What Should Be Inside? Outside?

From time to time I hear or read of consultants who say that you should never put stocks or mutual funds inside a registered retirement savings plan. Well, the word "never" doesn't exist in my financial planning dictionary. There are times when I would do something and other times when I wouldn't, but to categorize something as "never" is too restricting.

One of the "never" reasons is that you might not sleep well at night. It's a valid complaint and suggests that you not only refrain from putting equity-based investments inside your RRSP, but that you don't hold them anywhere at all.

Another reason can be that this is the pool of money that you are going to use to produce a pension in your retirement. Exposing it to undue risk could reduce your pension at retirement time. That's a valid complaint if you are planning to invest this money for only a short period of time. However, it's a proven fact that exposure to real estate, the stock markets or mutual funds over a long period of time will virtually always produce more funds than interest-bearing investments. Yes, timing it right can give you a better start. But, over the long run, say, 10 years or more, those who invest their money will do better than those who save it in an interest-bearing investment.

There is another common comment about investing your RRSP funds in equities, and, quite frankly, it has some merit. When we buy Canadian stocks or mutual funds outside our RRSPs we qualify for the dividend tax credit. This credit allows us to earn approximately $22,000 in tax-free dividends in a year if that's the only type of income we earn. Yet, if we earn dividends inside our RRSP we are not allowed to claim the dividend tax credit. As

a result, it appears that there is some merit to this argument. You are better off owning stocks and mutual funds outside your RRSP than inside. In addition, if we own stocks, mutual funds or real estate outside our RRSPs we qualify for tax-free capital gains until we exceed $100,000 ($500,000 for small business investments and farms). Inside an RRSP capital gains can compound totally free of tax, but once we remove the money we must pay tax on it at our normal income tax rate.

On the surface, then, it would appear that this last argument holds water.

Before we dismiss it let's consider one more fact. Yes, I agree that you lose the dividend tax credit and the tax-free capital gains. But, what if you have other forms of income that water down the benefits of the dividend tax credit? And what if you've already exceeded the $100,000 in tax-free capital gains? In that case you will definitely want to get as much money into your RRSP as you can since whatever yield you earn will compound tax free.

But even with all these thoughts maybe there is another reason why you would want to invest the funds inside your RRSP in mutual funds and/or stocks. It's the yield. That's right. It's okay to think about the dividend tax credit and the tax-free capital gains. But what about the numbers? What do they say?

Well, if you contributed the maximum allowable amount to your RRSP each year from 1967 until now you would have contributed a total of $91,000 to your plan. If you chose any investment that purely matched the rate of inflation you would have $178,191 inside your plan. Had you chosen a savings account inside your plan you would have a total of $196,484. So, you exceeded the rate of inflation. If you chose a five-year guaranteed investment certificate you would have $248,815. A short-term money market investment would do slightly better at $250,027. But that's the end of the normal interest-bearing RRSP choices.

There are hundreds of mutual funds out there. Some win and some lose. Had you chosen what is normally accepted as Canada's most recognized mutual fund, Industrial Growth Fund, you would have accumulated, in this example, a grand total of $489,326.

That's almost twice the yield earned on any of the normal choices. Yes, I admit that it would be better to own this investment outside your RRSP where you would benefit from the dividend tax credit and the tax-free capital gains deduction. However, to say you shouldn't hold it inside your plan would clearly be wrong, since you would be limiting yourself to interest-bearing investments that over the last 20 years have produced about half the yield available from the fund.

There is no question that you do not get the dividend tax credit and capital gains inside the RRSP. However, if long-term records show that you could get twice as much money why wouldn't you go for it?

If you could earn a pension worth 10% of your principal, the fund would, in this example, give you $48,932.60 a year compared to $24,881.50 with the five year GIC. Which would you rather have?

Why Settle for One RRSP when Two May Be Better?

There's no question that anybody with taxable income should consider using a registered retirement savings plan. But why stop at one? There are some valid reasons for having at least two of these plans.

Consider the young female who's either married or considering marriage. She should be putting the maximum she can afford into her own RRSP. When she marries, she should continue doing so but, if she's planning a family, her husband should also put as much as he can afford into a spousal RRSP. Now she has a personal plan and also a spousal one.

Let's say she decides to have a family. She leaves work so she has no income, or at least very little. As a result, she has no tax burden. That means that she can start removing the money from her personal RRSP without having to pay much, if any, tax on the proceeds.

In fact, she should be able to remove all the money from her plan over a three-year period without paying much tax.

Now she can start removing the money her husband has been contributing to her spousal RRSP.

Don't forget that any time we remove money from a spousal RRSP, the tax can be payable by the spouse who contributed the money in the first place. We can, however, insure that the tax is paid by the lower-income spouse if we remember one easy-to-follow rule. In this example, it says that the husband won't have to pay tax on the money removed from his wife's spousal RRSP provided no money was removed until three years after he made his last contribution.

Well, that's easy enough to handle here. During the three years

when his wife is removing money from her personal RRSP, he can direct his contributions into a personal plan in his own name. Once she's removed all the money from her personal plan, she'll be able to start removing funds from her spousal plan and be taxed at her low tax rate because her husband has, in fact, skipped three years of contributions to her plan.

By this time, she may decide to go back to work. If so, the family can start all over again. She'll contribute to a personal plan while he contributes to a spousal plan in his wife's name. That way she'll have double the contributions coming in to help offset the money that was already removed.

Once again, the family is back to earning two sets of deductions — and in fact they may look at repeating the removal process again sometime down the road.

One thing to remember, though, is the spousal tax credit. Once a spouse exceeds $500 in net income he or she is gradually reduced as a dependant tax credit. In essence, any income earned by your spouse in excess of $500 (net income) will be taxed at your top marginal rate as you will lose one dollar's worth of tax deductions every time he or she earns another dollar. As a result, you will often find that it's best to remove less than $500 or jump the number to around the $10,000 range. The rationale is that the first $500 was tax free and the amount earned by your spouse after you lose him or her as a dependant is also taxed at a low rate (or none at all). The combination works well.

Don't Be Afraid to Spread Your RRSPS Around

How many registered retirement savings plans do you have? One or many? For many taxpayers the answer is "one" since they simply go back to the very same institution each year. For others, the answer can be "one" because they don't have enough money in their RRSP to worry about exceeding the deposit insurance coverage. Yet others may answer "one" because they have a self-directed plan. All these RRSP users could be making a mistake.

There's no set answer to the question. Some taxpayers who have more than one shouldn't, some who have only one should diversify, others should vary their investment mix. As a result, they definitely will want to seek out a self-directed plan.

One of the common reasons for having more than one RRSP is for security purposes. Those who consistently seek out interest-bearing deposits in their RRSPs have to consider the safety of their money. That's why they choose GICs and term deposits in the first place — they get deposit insurance coverage. However, it's only good on the first $60,000 of accumulated interest and principal. Those who exceed that amount should consider one of several choices. Either have several RRSPs where they keep less than $60,000 in each, open a self-directed RRSP that has term deposits or GICs of several companies inside or switch some investments into government bonds, mortgage-backed securities, Canada Savings Bonds or treasury bills.

One complaint against the self-directed plan at this stage is its yearly fee (in most cases about $100). However, if you have several RRSPs that charge administration fees, or if there is a premature cancellation fee or a fee to move your plan, you may find the self-directed fee isn't onerous after all.

Many Canadians earn less than they could when they stick with only one RRSP. They simply go back to the same institution each year and accept whatever rate they're offered. Yet, had they shopped around I'm sure they could have earned a much better rate of return. That doesn't mean you should open a new RRSP at a different institution each year though. In fact, if the new institution you choose this year offers a better rate than you are already earning, why not switch all the money you have at other institutions to the new one?

In the past we used to recommend more than one RRSP for facility purposes. If you ever wanted any money out of your plan you had to cash the entire plan or go through some convoluted planning to get around this rule. However, in the fine print of the tax reform measures you'll find that it's now possible to remove part of the money from an RRSP. As a result, you no longer need more than one plan to satisfy this need.

Taxpayers with only small amounts in their RRSPs may also want to consider a self-directed plan. If you have all your money in a deposit-taking institution it may not be important. However, if some of your money is in stocks or mutual funds you may find a self-directed plan will save you fees even though you only have a small amount in your plan. Mutual funds charge trustee fees. If you have diversified into several funds you may be paying more than $100 a year in trustee funds already. Switching to a self-directed plan would ease your paperwork and may also cut your expenses. In fact, the more money you have inside your RRSP, the more value there is to using a self-directed plan. The fees look smaller all the time compared to the advantages gained.

Depending on the amount of money and the flexibility desired, a good case can be made for people never having more than one RRSP.

However, there are definitely examples where having more than one RRSP can be helpful. If you contribute to a spousal RRSP and your spouse also has earned income, it can be a mistake for that spouse to have only one plan. When you contribute to a spousal RRSP you will be taxed on any money removed within

three years of your last contribution even though your spouse may have also been making contributions. He or she might want to remove some of the money he or she contributed but it would still be taxed at your rate. In this case it definitely pays for your spouse to contribute to one RRSP and you to another. When he or she wants money, compare which plan would produce the lower tax burden and remove the funds from that plan.

Starting in 1990, we will no longer be able to contribute pension income into our own RRSP. We will be restricted to a maximum of $6,000 per year into a spousal RRSP. At that time it will become almost imperative that we have two RRSPS — one for personal use and one to accommodate the spousal transfers. At that time we may well want two RRSPS. Right now, though, it isn't always necessary.

Shorten Three-Year Spousal Rule

It's common knowledge that money contributed to a spousal RRSP must remain there for three years before it's withdrawn. Otherwise, the withdrawn monies will be taxed in the higher income spouse's name, and that defeats the purpose of a spousal RRSP.

When we contribute to a spousal RRSP, our thinking is that we, the higher-tax-bracket individual, will save on taxes, but our lower-taxed spouse will eventually pay the tax when the money is removed. That's great thinking, except that we must wait three full years after our last contribution before our spouse can remove it at his or her lower tax rate.

But that's not necessarily so. Through smart financial planning we can shorten that time frame substantially. You see, the three-year spousal RRSP rules are based on the calendar year. That means that the individual who contributes money to a spousal RRSP on the final day of February 1989 will get credit on his or her 1988 tax return. Because they have to wait until the first day of 1991 before they remove the money, they have really only kept their money in a spousal RRSP for 22 months rather than the required 36. As a result, they have faster cash flow plus some extra tax relief.

The choice of investments, through, may have some bearing on how well this idea works. If, for example, you choose a five-year term deposit inside your RRSP, you wouldn't be able to remove the money — even if you wanted to — before the five-year life of the term deposit has expired. As a result, if you want to put yourself in position to remove money from a spousal RRSP as early as 22 months from the last contribution, you should choose a short-term investment.

Who might want to take advantage of this idea? Well, young

people for sure. It's not uncommon for young couples to experience work disruptions as they raise families. They could save taxes at a high rate by having the husband contribute money to a spousal RRSP — with the wife removing it as early as 22 months down the road when she leaves work to start a family.

Investors could also use this type of planning. If one spouse has salary or pension income and the other only investment income, this idea may work well. The working spouse can contribute to a spousal RRSP. The nonworking spouse could purchase investments that compounded for three years at a time. That way the nonworking spouse could earn investment income for two years and remove the money from his or her spousal RRSP in the third year. The tax savings when the working spouse makes the contribution will be large. The tax bill when the nonworking spouse removes the funds will be small. The family, as a whole, pockets the difference.

Actually, you needn't restrict this type of planning to only once in a lifetime. It can be used every few years if your planning is right.

Get an Extra $300 Tax Rebate on Your RRSP

Normally, Canadians wait until the very last minute to contribute money to their RRSPs. When we do that, though, we play right into the hands of the taxman.

We can no longer earn $1,000 in tax-free investment income. However, all income earned inside a registered retirement savings plan compounds completely free of tax as long as the money remains inside the plan. There are absolutely no restrictions on the amount of tax-free income we earn until age 72 when the money must be removed from our plan. Even then, though, we can transfer the funds into a registered retirement income fund where we will gradually withdraw the funds by age 90.

Recognizing that, everybody who earns any taxable investment income should make it a point to contribute to their RRSPs at the very beginning of the year rather than waiting until the final deadline. The income earned by the RRSP will be totally tax free until it starts to produce an income in your own name. That should be many years down the road, and will give you years of tax-free compounding inside your RRSP.

For example, the individual who contributes $7,500 to an RRSP at the beginning of the year rather than the end will earn $750 tax free inside the RRSP rather than earning it outside his or her plan where it would be taxable.

For the average Canadian taxpayer that would create a tax savings of $262.50. For those in the higher tax brackets it could mean a savings of as much as $375 — which surely could be used elsewhere.

The point is that those who earn taxable income would be better off if they contributed to the RRSPs at the start of the year

rather than waiting until the normal deadline 60 days after the end of the year.

73

Letting the "Plan" Pay Can Save Taxes

The use of self-directed RRSPs is growing as Canadians accumulate substantially more money inside their plans. If you use one you'll find that there's a yearly administration fee that ranges from $50 or so to a couple of hundred dollars. At most institutions the administration charge has settled in at $100.

You have a choice as to how you pay this fee. You can either pay it out of your pocket in addition to your yearly RRSP contribution, or, if you prefer, you can pay it from the funds that are already inside your plan.

Back in the days when we could earn the first $1,000 in interest free of tax, we used to counsel taxpayers to contribute the maximum to their RRSP. If they had no hope of earning $1,000 in tax-free investment income we encouraged them to use the monies inside their RRSP to pay the administration fee. That way they had a little extra cash to invest outside their plan to help bring them closer to $1,000 in tax-free income. Actually, in most cases I would have preferred to pay the administration fee with "outside" money wherever possible because it's a shame to spend the money inside your RRSP when it could be used to provide tax-free compounding for a very long time. However, in this case there was merit because we have to pay tax sooner or later when we take the money out of our plan. But, if we hadn't yet reached the $1,000 tax-free limit we were going to earn tax-free income anyway.

Now that we've lost the $1,000 tax-free investment deduction it makes more sense to contribute the maximum to our RRSP and to use it all for investment purposes. All the income earned will be tax free inside our RRSP rather than taxable outside. Then you

should pay the yearly administration fee with additional monies outside the plan.

Now comes another important question. Is the administration fee tax deductible? Clearly, if we use monies inside the plan already it is tax deductible. I mean, we got a tax deduction when we contributed it in the first place. How we use it is up to us. However, if we pay it out of our pockets it can be difficult to justify a claim as it's not going to help us earn income at some time in the future. That's one of Revenue Canada's acid tests to determine whether an expense can be tax deductible: "Will it produce future income?" The RRSP is a trust. Having a self-directed RRSP should produce a larger retirement income down the road, so you can rationalize the expense. But, Revenue Canada feels it's the trust, not us, that will benefit. But the trust isn't taxable so it doesn't need the tax deduction.

Accountants say, though, that if the administration fee is paid directly to the company that it can be claimed as a tax deduction. In addition, financial-counsel fees are tax deductible so if this is claimed as a financial counsel fee you should be okay.

Because of the fees though, we generally recommend that taxpayers use a self-directed RRSP only after they reach $10,000 or so inside their plan. If, however, you own several mutual funds where you are being charged a trustee fee by each fund you may find the self-directed RRSP is less costly.

Benefits for the Young
RRSP Holder

The term "registered retirement savings plan" can scare many young taxpayers away from using these plans because they are young and have no interest in thinking about retirement. That's a shame since an RRSP should primarily be looked on as a tax-saving device, a "rebate savings plan," by young taxpayers. I mean, why pay taxes when you have these plans that will legitimately save you tax dollars? At the same time, the money inside the plan will grow at a much faster rate because it's compounding tax free rather than continually being taxed when left in your own name.

Consider these numbers. If a 30 year old saves $1,000 a year in his or her own name and earns 8% per annum until age 65 the pool of money will total $40,000. Clearly, it's worthwhile. If, however, the very same person saved the very same amount for the very same period of time and earned an identical rate of return, but did so inside an RRSP, the pool of money would total $185,000. That's right, an additional $145,000 for no more money simply because you used a savings plan (SP) with an "R" in front of it (RSP).

Unfortunately, though, we regularly procrastinate. That costs us twice. In the first place we pay more tax than necessary, and secondly, our money doesn't work as long for us and doesn't compound as rapidly. For example, a 30 year old who contributed $3,000 a year to an RRSP each year until he or she turned age 65 would accumulate $705,373.83 if the yearly yield earned an average of 9% per annum.

However, had this same individual begun contributions only five years earlier at age 25, he or she would accumulate some

$400,000 extra inside the RRSP even though there was only $15,000 (five years at $3,000) extra contributed. Where else could a young individual earn $400,000 so easily?

Clearly, it's extremely advantageous for a young person to start one of these plans as early as possible. In fact, if a 25 year old contributed only $1,000 a year to an RRSP each year until age 65 he or she would accumulate more than a 40 year old who contributed $3,000 a year until age 65.

There can be no question that the yield you earn is important, but so is the amount of time that the money can work for you. It's like an employee who's making a profit for you. The longer it happens the more you profit, even though you aren't doing the work.

A younger person can also benefit substantially by thinking and acting short term when it comes to RRSPs. For example, if you're working full time right now you're paying full-time taxes. If you plan to quit work to return to school, why not contribute the maximum to your RRSP while you are working? Save the tax rebates to pay for your tuition. Then, when you go back to school and your income falls you can remove the funds from your RRSP at a very low rate — if, in fact, you are taxable at all. At that time you'll have your tuition as a tax deduction, your standard deductions and the full-time student deduction. With these extra deductions and a lower income you can probably remove substantial sums of money from your RRSP tax free.

The same theory applies to anybody who is expecting their income levels to fall in coming years. If you are planning a family and expect to quit work to raise that family you can expect your income level to fall when you cease working. You will benefit by contributing the maximum to an RRSP now, when your income level is high, and removing the money later when your tax rate is lower — if, of course, you are taxable at all.

The other example I like to use is one that fits in perfectly right now. There are many Canadians with the entrepreneurial spirit. If you are working full time now but planning to start a business of your own an RRSP is a natural for you. You should

contribute the maximum to your RRSP now when you will get substantial tax relief. When you start your company you can use the tax rebates you've been accumulating as seed money. Then when you need more money you can withdraw amounts of money equal to the tax deductions generated by your company completely tax free. From then on if you want more money you can also remove it from your RRSP at little, if any, tax. You see, a good accountant can probably arrange the affairs of a new company in such a way that you can earn tax-free income for the first two years. That will allow you to remove money virtually tax free from your RRSP.

Yes, I know that RRSPs are generally looked on as being valuable to older people and being for long-term retirement purposes. However, these examples show you that these plans are actually very valuable for young taxpayers and very useful in the short term.

75

Administration Fees Can Be "Made" Tax Deductible

If you use a self-directed registered retirement savings plan, it may bother you that the administration fees are not tax deductible. But that's the way Revenue Canada treats them. It's felt that RRSPs don't produce taxable income, so there's no reason to allow fees as a tax deduction.

As a rule, fees usually run around $100 a year. However, if you buy stocks or mutual funds inside your RRSP, the commissions and the administration fees can run substantially higher.

If you have the $100 available outside your plan to pay these fees and choose to do so, you won't get a tax deduction. However, if at the same time you borrowed $100 to invest, the interest on that loan would be tax deductible. Now you've created an equal tax deduction that effectively makes your $100 the equivalent of a tax-deductible expense.

It's simply a matter of selling $100 worth of investments and then borrowing to buy similar investments; now you have a tax-deductible expense.

You might also want to look at covering your commissions in the same way. When incurred inside an RRSP, they aren't tax deductible. However, if you bought stocks or mutual funds outside your RRSP, paid the commission and then waited for them to appreciate, the gain would be tax free. If that gain equalled the commission, you're right back to your original investment tax free. When it's contributed to your RRSP you get the full tax deduction. Effectively, your commission is tax deductible.

76

Make RRSP Loans Tax Deductible

Prior to 1981, we used to be able to borrow money to contribute to an RRSP and make the interest cost tax deductible. The 1981 budget ended that right. However, all loans that were already in place can still be considered tax deductible with the interest cost creating tax relief as long as these loans are still in place. In addition, those who take out new loans to contribute to RRSPs can also make those loans tax deductible. It's simply a matter of arranging them properly.

For example: Let's say you have some stocks, bonds, CSBs or mutual funds in your name right now. You don't want to cash them in as you expect further appreciation in their value. But maybe you should. If you cashed them in and used the proceeds to contribute to your RRSP, you'd then be able to buy back the very same or different investments with borrowed money. That loan would be considered an investment loan — and the interest paid on investment loans is considered totally tax deductible.

In essence you've made your RRSP loan the equivalent of tax deductible.

When you cash these investments you may not be too excited about the prospects of paying commission. You may feel that selling one day and then buying right back with borrowed money will create a double commission that will eliminate the advantages of this tax-saving idea. Well, don't worry. When you sell investments in this way you don't necessarily have to use a broker or pay a commission. You can always sell the securities privately, use the proceeds for your RRSP contribution, and then borrow to buy them back. It will make your RRSP loan much easier to service.

RRIF **Better Choice Than Annuity**

While most Canadians choose to remove the money from their RRSPs via an annuity, or by outright cancellation of their plans, there's now a better choice. It's called a registered retirement income fund or RRIF for short.

Why is an RRIF better than the other choices? It offers more flexibility, lower tax rates, and the return of more of your money than you'd normally get. That's why.

Under the old laws, we were only allowed one RRIF in a lifetime. Now we can have as many as we want. We used to be restricted to a smaller monthly income than we could get with an annuity, but now we can pick whatever we want, without restriction. With an annuity we never got our money back, just a monthly income. With an RRIF we get back all our original money plus all the investment income earned inside the plan.

So, clearly, there's now much more flexibility with an RRIF than with an annuity. And, of course, when it comes to comparing the RRIF to the third option — that is, to collapse your RRSP outright and pay full tax — it's even more important to choose the RRIF. If you cash in, you pay full tax. If you choose the RRIF, you can spread the tax liability over 20 to 30 years. In fact, with proper tax planning you can actually get most or all of the money out of your RRIF totally tax free.

To show you how attractive these plans now are, consider these numbers. If you have a registered retirement savings plan and you go the annuity route at age 71 you'll receive almost $12,000 a year lifetime income. In addition, it's guaranteed to last at least 15 years in case you predecease your spouse. In 15 years, then, you will have received a little more than $177,000.

Unfortunately, though, because you've had no inflation protection, your income is now worth only 25 cents on the dollar.

Instead, you could choose an RRIF. If you were able to earn 15% on your money inside the plan while taking the very same income as you were going to from the annuity, you'd still have $218,000 inside your RRIF 15 years from now. It would continue to produce an income for the rest of your life and for the rest of your spouse's, and still leave a sizable amount for your heirs when both of you pass away.

With the annuity everything stops when you die, although in this case there is a 15-year guarantee. And, if you live, you have to recognize that inflation will gradually destroy the purchasing power of your fixed-income annuity.

If you chose the RRIF instead, you'd have the flexibility to increase your income to $15,000 after five years and, let's say, to $20,000 after another five years. And even while you're protecting yourself against inflation, you'd still have $120,000 left after 15 years. That will still earn a pretty healthy income for the rest of your years.

The new RRIF rule works very much in your favor, so make sure you consider them, as well as an annuity, when it comes time to remove the money from your RRSP.

When You're Out of Work, Why Not Retire Early?

Times are tough from time to time. In fact, after the bout of extremely high interest rates in the late 1970s and early '80s, when so many companies went bankrupt and so many jobs were lost, corporations have been slightly gun-shy when it comes to hiring new staff while, at the same time, they have had itchy fingers when it comes time to dump staff.

If you're one of those who's lost a job, you might want to give some thought to attacking your registered retirement savings plan.

Yes, these plans are meant to help supplement our retirement, but they aren't restricted to that use. When you contributed to your plan you were probably in a higher tax bracket than you are in now when you don't have a job. In addition, the money you put inside the plan has been growing tax free inside your plan. Yet if you remove some of it while you are out of work, you'll probably pay less tax than you saved when you contributed the money in the first place. In fact, if you've been out of work most of the year you probably won't have to pay any tax on the proceeds at all. The money will do you a lot more good in your hands now than it will years down the road when you retire.

There will be some withholding taxes when you collect the money from the institution. But if you aren't taxable, you'll get the withholding taxes back when you file your tax return in the spring. If you are taxable, the extra you owe or the amount owing to you will be sawed off at tax time. If you are taxable, and get your job back, you can always recontribute to your RRSP.

Of course, one thing you will have to look at is your expected income. When it comes time to recontribute this money back into your RRSP you will be restricted to either $3,500 or $7,500 or

whatever the maximums are at the time. As a result, you may not be able to put back everything you removed.

If you are a pensioner you can really benefit from this idea. In 1989 you can roll as much of your pension income as you can afford into your RRSP. As a result, you can get away with removing an amount equal to your expected pension income at the beginning of the year. You can then recontribute it later on. It's like getting an interest-free loan each year. Don't forget though, that there will be some withholding taxes to pay each time you remove money from your plan. However, if you recontribute you will now qualify for a nice fat tax-rebate cheque each spring.

From 1990 to 1994 pensioners will be limited to rolling $6,000 of their personal pension into a spousal RRSP. Government pensions don't qualify though unless they are for personal services.

Even with the reduced amounts, we may be able to benefit. You see, income splitting is a valuable tool whenever we can use it to move money out of the higher-income spouse's name into the lower-income spouse's. If you, the higher-income spouse, have a substantial sum of money inside your RRSP but your spouse has very little it could be valuable to remove $6,000 from your RRSP and roll over a like amount of pension into your spouse's RRSP. The family still has the same amount of disposable income but, when it comes time to draw a pension from your RRSPs, more will be taxed at the lower-income spouse's rate.

There are two important considerations. Don't forget that you will have to pay withholding taxes when you remove the money from your plan, but you will get it back when you file. And this idea will work only until the end of 1994 so it pays to get on it right away.

Life Insurance Can Even Pay Off While You're Alive

Most of us look on life insurance as something that will help our heirs when we die. However, there are ways to advantageously use our life insurance while we're alive, and get some tax relief at the same time.

For example, if your are borrowing money for investment or other purposes, and the lender wants the loan life insured, the premiums you pay will normally be tax deductible.

When we buy life insurance to protect our family, the premiums aren't normally tax deductible as we aren't looking to earn money with this policy — we're simply using it as protection. Revenue Canada demands that expenses we incur can only be tax deductible when they are undertaken for business purposes.

Ah, ha. But when we are ordered to buy life insurance to protect a loan or for business purposes then the premiums are, indeed, tax deductible.

Lots of lenders offer life insurance on loans anyway. In that case the premium is often incorporated in your monthly payment. If the interest is tax deductible so, too, is the insurance portion. In that case we don't have much problem. In the instance where we go out and get a separate policy, though, that's when we often forget to claim the insurance premiums as a business or investment expense.

When in doubt ask the agent, the financial planner or the lender.

Pensioners Can Earn Loads of Tax-Free Income

It's a shame, but it's commonplace for Canadians to direct most or all of their savings toward things like term deposits and Canada Savings Bonds as they get older.

The rationale is great. The older you get, the more secure you want your investments to be. And those investments are very secure. The problem, though, is that all the income produced by them is interest, and now all interest is taxable.

If, instead, you purchased something — say, cases of canned food that wouldn't spoil — and sold it off over the next few years you'd be able to create a regular income, and normally one that would rise in value. You see, inflation will push the price of those canned goods higher each year. The first money you get back will be your own. It, naturally, is tax free as it's simply the return of your own money. From then on you'll be earning a capital gain, which, under today's laws, is tax free until the $100,000 mark.

If you earn 10% a year interest, it's taxable. If you earn 10% capital gain through selling these products, it's tax free when it's within the maximum limits. The income is the same but the tax burden is much more attractive.

Most of us aren't into canned foods, though. But that's where something called a systematic withdrawal plan can be useful. Mutual fund companies invest your money. Each month they pay you an income. It's only the return of your money so it's tax free. In addition, they pay you some of the capital gains that are earned on the money. You have virtually tax-free income.

For example: I remember a case where a pensioner was selling his house to move into a rental unit. In the first place I recom-

mended that he buy a condo so he would have the advantage of a tax-free principal residence. However, he decided he wanted a rental unit. If he invested the $100,000 (the money he was going to net out on his house sale) in term deposits he would earn about $12,000 a year. With the loss of the $1,000 tax-free investment income deduction he was going to pay full tax on all the income the term deposits paid. Yes, he could have tucked the money away in raw land, art or antiques that would have risen in value but he felt he wanted a monthly income from his investments to supplement his pension income. Rather than the interest-bearing investments, he could have invested his monies in a systematic withdrawal plan with a mutual fund company where he would have received the same amount of monthly income but paid much less tax. For example, Templeton Growth fund would have paid him the same $1,000 a month but because it was really the return of his own money he would have paid much less tax. In fact, if he chose the term deposits he would have paid about $4,800 tax on his $12,000 interest income. If he chose the mutual fund he would have paid $173 in tax. The difference is close to $400 a month in after-tax income which surely would have added to his lifestyle. His other alternative, and a better one in my mind, was to reduce his monthly withdrawal plan to about $900 per month. The after-tax yield was still better than he would net from his interest-bearing investment. In addition, he wouldn't be attacking his mutual fund investments to the same extent so they would compound that much faster.

81

Savings Plans — Don't Forget Important Deductions

Canadians are big savers. However, we are also big losers when we don't take advantage of legitimate tax deductions that are allowed once we start to earn investment income. And don't think that investment income means the stock market or real estate. No sir. We're talking about things as elementary as savings accounts and Canada Savings Bonds.

The first consideration is safety. While many consumers may hide their cache of savings in the basement, most use safety deposit boxes. If you declare interest or other investment income on your tax return, you can deduct the cost of renting a safety deposit box. If you're into stocks and bonds, you may be charged a safekeeping charge by the financial institution or stockbroker. Or you may pay banking charges to have the securities delivered and cheques crossed. These charges are tax deductible. Commissions, per se, are not tax deductible, but it *is* important to calculate commissions because they will lower your capital gains.

Other deductions we should claim include portfolio management fees paid to a bank or trust company, accounting fees, bookkeeping fees, investment counselling fees and investment literature and courses (see Tips 36 and 91), and interest paid on investment loans. Many consumers buy Canada Savings Bonds on the payroll deduction or monthly savings plans. This is really a loan that you pay off over a 10-month period. The interest is normally calculated at the same rate as you earn on your CSBS. This year for the first time we must pay interest on every penny worth of interest we earn, so it's even more important than ever before that we claim the interest we pay on payroll deduction plans as a tax deduction. In fact, when you look at it closely it's

this fact that will ensure that interest on investment loans remains tax deductible for many years. If we had to pay tax on our CSB interest but were refused deductibility on our payroll deduction costs, we would no longer buy CSBs on payroll deduction plans.

Your employer has information on the cost of buying these bonds on payroll deduction and will provide you with them whenever you ask.

The interest paid on any other investment loans should also be claimed as a tax deduction. After all, if all investment income is now taxable to some degree it's more important than ever before that we claim the expenses we incurred to earn these monies as a tax deduction. In essence, we are operating a business when we invest. Businesspeople get tax relief — so too, should we.

Don't Use the Government as a Forced Savings Plan

Would you believe that millions of Canadians purposely use the tax return to create a larger than normal tax rebate each spring? Here's what they do. They purposely leave a dependant or two off the exemption list they file with their employer each new year. In fact, some who are married go as far as to claim themselves as single.

Why? Well, their thinking is that there will be more taxes deducted from their paycheque all year long. But when they file their tax returns each spring, they'll claim the spouse and/or children that they've had all along. Now they'll get a much bigger tax rebate which they can use to finance a summer vacation. For some, the money may be used more constructively, such as to buy investments, pay off debts, or pay down a mortgage. Those are all great ideas and well worthwhile, but to save the money this way is a mistake.

All you're really doing is playing into Revenue Canada's hands. Your employer is obliged to remit these excess taxes to Ottawa every two weeks. That means that Revenue Canada has your money from mid-January right through until the day you receive your tax rebate. That can be 15 to 16 months down the road.

Surely you could have used that money to your own advantage in that time period!

Many taxpayers respond that it's the only way they can save money. It automatically disappears from their paycheques so they can't spend it until they get their rebate cheques in the mail.

Well, that's not really the case, you know. There are lots of other ways to set up a forced savings plan that will accomplish the same thing.

For example, why not continue to use Ottawa to provide your forced savings plans? But make it a different agency where you get paid interest rather than lose it. Each November Ottawa sells billions of dollars worth of Canada Savings Bonds. In many cases your employer will automatically deduct money from your paycheque to buy these bonds from the Bank of Canada. There's your forced savings plan. But instead of your earning no interest on the money that prematurely goes to Revenue Canada, this money earns the going CSB rate of interest. In addition, you have more flexibility. You see, you cannot retrieve your tax rebate until you file your tax return. CSBS can be cashed any time you want.

Another idea would be to have your paycheque automatically deposited in a savings account at a financial institution. Then you would authorize the manager to remove an agreed upon amount from the savings account each pay. Once again you have a forced savings plan that earns you a little something during the year.

Or what about increasing the size of your mortgage payment? And if you switch to a weekly mortgage with a larger payment, you can automatically pay your mortgage off in close to half the normal time. Or what about a monthly purchase of stocks, mutual funds or even a registered retirement savings plan?

Don't let your employer withhold too many taxes from your paycheque. It costs you in the long run.

83

Dividend Reinvestment Programs

Without question, most investors can trace their greatest investment successes to forced savings plans, that is, entering into an obligation to steadily and regularly buy or pay for investments.

A house is the best example. Few of us can afford to pay cash for a house. Instead, we scrape up a down payment and force ourselves to make monthly payments until the loan is paid off and we own the property lock, stock and barrel. We may find a little money from time to time to accelerate the mortgage paydown, but it was the constant, systematic payment plan that made it work.

Some people refer to this theory as a forced savings plan; some look at it as dollar cost averaging. It can be used with housing, systematic purchase of stocks, mutual funds and other investments — and it's growing in popularity with small- and medium-scale investors who already own investments that produce a regular yield.

You see, if you have enough money to buy investments you probably don't need the yield, unless, of course, you have retired and use the investment income you earn to supplement your pensions. If you don't need the yield, yet take it, you will pay tax in most cases, and may incur commissions and other expenses to reinvest those funds. However, there is a way to ease some of these burdens. It's called a DRIP — a dividend reinvestment program.

These programs have long been offered by mutual fund companies and now are being introduced by a growing number of Canadian corporations. They make and save money for the investor and they provide a constant source of income for the corporation.

Here's how they work. If you presently own shares of a mutual

fund or a dividend-paying corporation you receive dividends several times a year. If you take the dividends you pay tax on them (if you are taxable) and then spend the money or reinvest it. If you reinvest it in shares of that fund or company, or another one, you probably pay commissions when the purchase is made.

However, more than 100 companies and many of the mutual funds now allow existing shareholders to automatically reinvest those dividends right back into more shares commission free. If you like the company where you are dealing this is a nice way to save some costs and continually accumulate a larger holding. If you don't need the yield you are earning why take it? Why not reinvest it somewhere? If you like the company in which you are presently investing why not stick with it?

Saving commission costs is only part of the story. Many of the companies that offer dividend reinvestment plans also offer investors the right to buy additional shares at reduced cost. They recognize that a constant flow of new money reduces their need to borrow money or issue new share offerings.

For example, many companies allow investors to purchase shares with their dividends and also to buy enough additional shares to reach the next board lot (usually in multiples of 100 shares). Or, they may allow you to buy a set percentage of the shares that you already own. Effectively, by owning shares of that company you've been encouraged to buy more because they're commission free. There can also be an added bonus. Many companies actually reduce the price of their shares to existing shareholders who wish to add to their dividend reinvestment plans. There are numerous examples of companies that are happy to lower the purchase price of their shares by 5% and charge no commissions in this instance. Investors who use these accelerated purchase plans can get even cheaper exposure to their favorite investments.

Those who wish to "time" the markets, that is, buy when prices are low and sell when they are high, don't really like these purchase plans, since systematic investment means constant buying no matter what the price is. However, few ordinary investors

are successful at buying at the bottom and selling at the top. As a result, the success ratio for ordinary investors is overwhelmingly in favor of systematic purchase plans.

There is some confusion as to the tax status of dividend re-investment plans. If you own shares of Bell Canada, for example, you can reinvest your dividends in new Bell shares. Those dividends, though, must be claimed on your tax return as taxable income. Simply put, even though you didn't actually receive the dividends it's considered that you did, and that you subsequently sent them back to the company to buy new shares. However, if you receive Canadian dividends you are still entitled to claim the dividend tax credit to eliminate most or all of the tax on those dividends.

Not all companies offer these plans. Even when a company does it might not be advantageous to enroll. The best choices are ones that consistently pay a good yield and regularly increase their dividends. Included are banks, utilities and steel companies.

84

Make Sure You Borrow for the Right Purposes

Far too often, we make the mistake of borrowing for the wrong things. As an example, we own some Canada Savings Bonds and we're considering buying a car. If we borrow money to buy the car, the interest won't be tax deductible unless we use the car for business purposes. Yet, interest on loans taken for investment or business purposes is, in fact, tax deductible. Realizing this, we'd be better off cashing in our bonds to pay cash for the car and then borrowing money to buy new bonds or other investments. Now the interest on that loan is tax deductible and part of it is picked up by the taxman.

The reverse has an individual using cash to buy business equipment, parts, supplies, or again, a car. The interest we pay on loans taken out for business purposes is tax deductible, even if it's only a part-time business. In this case we'd be better off borrowing for all these things while we pay cash for our vacations, personal use items, mortgages and any other item where interest would not be tax deductible. We may actually get another bonus here in that business and investment losses can be used to lower our taxable income from salary or investments. As a result, the taxman may pay part of the interest and give us back some of the taxes we already paid.

This year we have new tax rules called CNIL (cumulative net investment loss) rules that make it more beneficial to claim business losses incurred when we are actually operating a business before we claim investment losses. As a result, it's better to borrow for business reasons first, investment purposes second and personal uses last.

153

85

A Loan Can Unite the Family

We used to be able to save taxes by splitting the family assets between spouses and even other family members. Ottawa did its best to eliminate income splitting from our bag of tax saving tricks. Now we have to work a little harder to accomplish it. It's still worthwhile, though, as any time we can shift income from a high-level taxpayer to one in a lower tax bracket, the family will save taxes.

One way to accomplish that is to arrange for the lower-income spouse to borrow money for investment purposes. The higher-income spouse may have to guarantee the loan. However, lodging the investments that are purchased as collateral may be all that is necessary.

The next step is to pay the interest. To accomplish that, the higher-income spouse can give enough money each month to the lower-income spouse. If the lower-income spouse were to invest this money the income earned would be taxable on the donor's tax return. But the lower-income spouse doesn't intend to invest the money. It's going to be used to service the debt on an investment loan.

The net result, hopefully, is that the investment will produce a higher rate of return than the interest expense. The difference will accumulate in the lower-income spouse's name which is exactly what we are trying to accomplish.

In the early years, in fact, the lower-income spouse may not even be lost as a dependant exemption. The interest is tax deductible before calculating net income. As a result, it's only the income earned after deducting expenses that will be taxable and used in determining dependant status. In addition, if the lower-income spouse chooses stocks or mutual funds, the income can

be part capital gain and part dividends where very little tax is payable. If it's real estate, there will be a capital gain plus rental income that can be offset by expenses.

Borrowing to Invest in a Foreign Country

In the past we borrowed for foreign investments while we paid cash for those classed as Canadian. The theory was quite simple. When we borrowed to buy Canadian investments the interest costs had to be claimed against interest earned before we could claim the $1,000 investment income deduction. Foreign investment income didn't qualify for the $1,000 tax-free investment income deduction so we could offset interest paid against interest earned and still claim the investment income deduction against our Canadian investment income. However, this year, for the first time, we can no longer claim the $1,000 deduction. As a result, it doesn't make any difference whether we borrow for Canadian or foreign investments. The same rationale applies when it comes to claiming tax-free capital gains. No matter where they are produced we can use them as part of the $100,000 tax-free capital gains deduction.

Those who believe that interest expense is no longer tax deductible are making a serious mistake. It is still *very* tax deductible. And, it matters not which country you choose.

87

If You Borrow Against a Life Insurance Policy, Try to Make It Tax Deductible

Taxpayers who own cash value life insurance policies normally know that they can lodge it as collateral if they need to borrow money. However, far too often they don't realize that they have value in the policy itself that they could use to their advantage.

Often the insurance company will lend them most of the built-up cash surrender value, and normally at an interest rate below that offered by most lenders. In fact, if you have an old life insurance policy taken out in the 1960s or earlier, you have the right to borrow at rates as low as 5% and 6%.

There's an extra advantage, though, when you borrow that money to invest elsewhere. The interest we pay on most invest-ment and business loans is tax deductible. And as 5% and 6% loans are scarce as it is, a *tax-deductible* 5% or 6% loan is even better.

That's why we want to make the best possible use out of this type of loan. Sure, we can borrow from a policy and pay for our next trip, and yes, the cost would be a little lower because of the lower interest rate. However, borrowing from a life insurance policy for investment purposes would be even better. Then a 6% loan would cost only 3.6% for somebody in the 40% tax bracket, a 5% loan only 3% after tax.

When you borrow against a life insurance policy in this way it looks pretty simple. Borrow at 5% or 6% and earn twice as much. However, it's not quite that simple. In the first place bookkeeping is important. If you don't bother to declare the interest you paid you don't get a tax deduction. If you don't

bother to invest the money properly you won't earn as much as you should. And, if you borrow too much you can be taxed.

Here's what can happen. If you borrow more than your adjusted cost base you are not just getting back your own money, you are making a profit. As a result, it's important that you have your financial planner or insurance agent assess the value of your policy before you borrow the entire cash surrender value. It's great to get a low-cost loan but it's not so great to pay tax on your own money. Once you borrow more than this policy cost you could pay tax on your profits.

A Loan from Your Boss May be Tax Free

In the past it was a great idea to borrow money from your employer at little or no interest cost. You could buy a bigger and more expensive house without having to pay a larger mortgage payment.

Well, Revenue Canada didn't care for this idea. They felt that you were getting a tax-free benefit from your employer. As a result, they made some substantial changes to the rules. However, it can still be beneficial to get a low-cost loan from your employer.

First of all, what qualifies as a loan? Well, if your employer lends you money or arranges for you to be able to borrow it at a beneficial rate, or offers the same conditions to a family member (e.g., a student for tuition purposes), you are considered to have received a benefit.

If you borrowed $10,000 from your employer at 4% and the government-set "prescribed rate" (usually set every quarter by the federal government — and usually the rate they pay us on late tax rebate cheques) averaged 10% all year you would have received a benefit of $600 (10% less 4% times $10,000). You would be required to claim the $600 as a taxable benefit on your tax return prorated, of course, to cover the portion of the year the loan was outstanding. Even then, though, it's a cheap way to get a loan. But there are ways where it can be even cheaper.

If you borrow money from your employer to buy a new house, the prescribed interest rate that determines your taxable benefit is deemed to be the lesser of the rate in vogue at the time you made the loan and at present. Accordingly, it pays to take a short-term loan when it looks like rates are going to fall since your taxable benefit will gradually fall as rates fall. All you have to do is renegotiate your loan every quarter. If, however, it looks

like rates are going to rise you won't want to change the terms of your loan.

If you are relocated by your employer, are required to buy a new house and can claim moving expenses as a tax deduction, you can get a break on the first $25,000 worth of housing loans received from your employer. Effectively, you do not have to include as a taxable benefit the gain you enjoyed on up to $25,000 in home relocation loans. You can enjoy this benefit for as long as five years.

Naturally, if you borrow money from your employer at the going rate or higher you do not have to worry about claiming any taxable benefit since you have not gained any advantage.

Many employees are encouraged to borrow money to buy shares of the company where they work. It improves employee relations. You own shares of the company so you prosper as it does. As a result, you may actually become more productive.

If you borrow money from a normal financial institution to buy shares of any company including the one where you work you can claim the interest as a tax deduction. Accordingly, the same theory applies to loans from your employer to buy shares in the company where you work. In this case the interest will be tax deductible as it is an investment loan. That tax deduction will offset the tax on the taxable benefit you claim on the lower cost of the employee loan. You own shares in your company and the tax cost is offset by the tax breaks.

The advantages offered by employee loans are not as attractive as they used to be. However, employee loans are still generally advantageous.

If you can borrow at a lower rate than you would pay at a financial institution and only pay your tax rate on a portion of the taxable benefit you have a pretty good chance of coming out ahead. In addition, if you believe in the company where you work you will probably benefit in the long run by owning shares in that company.

It Doesn't Pay to Cash Some Old Loans

While we should always try to pay off all non-tax-deductible loans as fast as possible, we don't have to act as quickly when it comes to investment loans as they *are* tax deductible.

There is one type of loan that creates extra confusion. It appears not to be tax deductible but in many cases it is. If it weren't tax deductible, it should be paid off as soon as possible. However, if it is tax deductible, it's better to put it at the bottom of the list — and pay it off last.

The loan in question is an old RRSP loan. Until 1981, we were allowed to claim the interest we paid on RRSP loans as a tax deduction. Since then, no such luck on new loans.

The point is, though, that these loans should not be paid off ahead of non-tax-deductible loans like mortgages and credit card balances because the interest on these tax-deductible RRSP loans is much lower than on a non-tax-deductible loan.

You should segregate any old RRSP loans from your other loans. In addition, you should continue to separate your tax-deductible loans from non-tax-deductible ones.

The order of payment should be against non-tax-deductible loans, then tax-deductible ones — and finally those that were originally taken out for RRSP contributions when these loans were still tax deductible. While interest rates should still play a role, the thinking here is that a typical investment loan can always be replaced by a new one down the road. Once the old RRSP loan is paid off, it can never be replaced.

90

Pay Cash for Gold, Raw Land

There's always been a great deal of controversy over which investment loans are tax deductible and which aren't. The courts seem to have made up their minds recently though — and here's what they said.

To make interest on investment loans tax deductible, we must meet two requirements. The first is that we must earn a regular yield when we invest the money; the second is that there must be some potential for future profit. We can create all the losses we want along the way as long as we earn some kind of regular yield and as long as we can show Revenue Canada that there's a reasonable expectation of a profit sometime in the future.

Gold might be one investment that consumers should consider borrowing for. It shows the potential for future profit, but that's the only way you make money with gold — you sell it at a higher price. Revenue Canada has now determined that we cannot claim the interest we pay on loans taken out to purchase gold as a tax deduction. There are other ways to play the gold game where the interest is tax deductible. You could buy shares in a producing gold mine, a gold fund or a mutual fund with exposure to gold or shares of gold producers.

We have the same problem with raw land. Unless it's producing an income, the interest won't be tax deductible unless we're in the business of developing land. Of course, if we are we'll have to add the income we earn when we sell the land to our other income and pay full tax on it rather than earn a tax-free capital gain when we're simply an investor.

There are other ways to get involved in the real estate markets where the interest we pay can be tax deductible. Included are real estate trusts, shares of real estate companies, rental prop-

erties, farms, Christmas tree farms — or, at least, pick raw land that can be farmed, used as parking lots, or used in some other way to produce an income. That way the interest we pay is tax deductible so we save taxes while waiting for future profits.

When we buy investments it's best to buy ones that are multi-dimensional in scope. That is, they produce an income on a regular basis so we have some help in maintaining that investment throughout the years. At the same time they produce the potential for a capital gain. When we borrow for investment purposes it's even more important that there is some regular yield to help us pay the interest and other carrying charges while we wait for a capital gain. It's that combination of yields that also gives us the right to claim tax deductions.

If You Pay to Learn, You May Be Paid to Read

Lots of Canadians buy money-management books such as this one, my other bestseller *Your Money and How to Keep It* and my popular tax-return book, *Brian Costello's Step-by-Step Tax Guide*. Or they may subscribe to newsletters that tell them how to manage their money and save taxes. The question, naturally, is whether or not these expenses are tax deductible as investment expenses.

Revenue Canada has some guidelines when it comes to this type of expense, although they are rather vague. However, I think we can gather enough from them to set some of our own guidelines.

If you buy a library full of books, you have to depreciate the value of the library each year rather than claim the cost as an outright tax deduction.

However, if you subscribe to newspapers, newsletters and manuals that change regularly, then you have a reasonable argument that they are tax deductible. Naturally, you'll have to prove that they are useful in your business or that you are active enough as an investor that they will indeed increase your investment income. That's an important consideration as it will help Revenue Canada feel that they'll be in for their share of a bigger pie down the road.

When it comes to money-management books, the same criteria apply. If the information is of the textbook nature that won't change very often, you may run into problems. However, if it regularly changes, as in taxes and money-management rules, you have a much better chance. In fact, with that type of book it's better to claim it and perhaps be refused rather than not claim it at all.

Stock, Mutual Fund and Real Estate Commissions Aren't Tax Deductible — Or Are They?

Normally we think that commissions paid to buy real estate, stocks or mutual funds are not tax deductible. However, they can be if we manage our money properly.

Normally, commissions aren't claimed as a business expense. Instead, they're added to the cost of the property or subtracted from the proceeds of a sale. That lowers the capital gain effectively giving us some tax relief on the commissions we pay.

But capital gains are now tax free, to $100,000 each in a lifetime. Some taxpayers, though, will exceed the yearly — and lifetime — limits. In that case, it's really important that we continue to claim our commissions when calculating our capital gains. In addition, a portion of our capital gains must be added to our normal income when we calculate the new minimum tax. So even though capital gains are tax free, they are in fact part taxable. Claiming commission expenses, then, can save some of these potential tax bills.

When you calculate your capital gains you should take your total out-of-pocket cost and subtract it from your net after expenses and commissions receipts. That way the capital gain you claim is the "pure" capital gain, the amount received after expenses. You'll erode your tax-free capital gains slower and pay less minimum tax. As a result, your commissions will be partially tax deductible. Once you exceed $100,000, they definitely are.

93

Real Estate Income Isn't Always Taxable

For some reason or other there seems to be great confusion over how to treat mortgage interest when you own two pieces of real estate. Handle it properly and you get tax-deductible interest expense. Make a mistake and you pay not only today's high interest rates but also get refused interest deductibility.

Here's what seems to be happening. Canadians who have paid off their mortgages or built a substantial amount of paid-up equity in their homes are buying a second property. It stands to reason that if you own two houses and borrowed money to produce rental income that the interest will be tax deductible. And, it can be — but only when handled properly.

For example: If you own a house in which you presently live and you borrow money against it to buy another house that you intend to rent you won't have much trouble with Revenue Canada. You see, in their eyes you have borrowed money to make money. They expect to share in your profits sometime down the road so they will generally accept your idea.

To make the interest on a loan tax deductible Revenue Canada demands that the investment you purchase produce a regular income *and* some expectation of a future profit. Rental real estate generally meets both requirements. If it's already constructed it should produce rental income and normally real estate rises in value. By the way, the rents do not have to exceed the cost of operation. In fact, that's one of the great advantages of real estate. If you finance it properly it can manufacture tax deductions that will save you taxes owing on other types of income.

Here's where problems develop, though. Many taxpayers believe they can buy a new home in which to live, rent out the existing

home and still claim the interest as a tax deduction. In some cases it works but in most it does not. Let's examine what they've done. They live in a house that's paid for in full. They have great equity on which to borrow, so they do. But then they make the critical mistake. They use the money they raise to buy a house in which they plan to live. There's all kinds of hope for it to turn a future profit. But there's no hope of a regular income as they intend to live in the new house, not rent it out. It matters not that they intend to rent out their original house. They borrowed the money for house number two — and there will be no income generated by that house.

If interest deductibility is important they should handle this transaction differently. They could stay in house number one, borrow to buy house number two, rent it, and they have no problems (other than those created by being a landlord). They could sell house number one, use the proceeds to buy house number two in which they live and then use it as collateral to purchase house number three, which they rent. Now, the money was borrowed to produce rental income and a potential profit — and Revenue Canada should be happy.

There's also one other idea that could prove interesting. If you really want to hang onto property number one and also get interest deductibility, you could sell house number one to a friend, buy house number two, in which you plan to live, for cash, and then borrow against it to repurchase house number one from your friend. Now you own the two properties you originally desired and you have interest deductibility.

There are two problems with this final idea. The first is the fees it will attract. You may be able to negotiate with a lawyer and you won't need a real estate agent. However, you will have to face up to land-transfer taxes and other closing fees. In fact, you may have to pay them twice.

In addition, you may also attract the attention of Revenue Canada. As part of tax reform Michael Wilson has implanted some bicuspids into the tax avoidance rules. If Revenue Canada

feels you have done something purely to create tax deductions they can refuse to accept that transaction.

Your lawyer and real estate agent can be a big help in making sure these transactions are handled properly and with the least expense. I mean, if you go ahead and borrow against house number one to buy house number two, in which you plan to live, it might take three years for Revenue Canada to spot the error. All of a sudden you may be responsible for three years' taxes on all the interest you claimed. It's better to do it right in the first place.

When Planning, It Pays to Look to the Outskirts

If you are earning taxable investment income that you don't need, it hardly makes sense to earn more. It only increases your tax burden.

Instead, why not buy a piece of property on the outskirts of town and let its value rise over the years? The gain is tax free until you sell it and even then it will be treated as a tax-free capital gain as long as you are under the $100,000 limit.

In fact, this is a tactic that should be practised by homeowners who may want to move elsewhere sometime in the future. You should look for a piece of property on the outskirts of town where you might want to live.

If you buy it at a decent price now you can enjoy double inflation protection. The value of your present house will rise, offsetting inflation, while you will also enjoy protection against inflation on your new property. As the city or town where you live expands, your property will rise in value. When it comes time to build you have several options: you can sell your house and build on the new property; you can sell both properties and move to another one; or you can work a swap deal with the builder whereby he buys your house and builds on your property or another one.

You come out with double inflation protection and can save transfer taxes, real estate commissions and capital gains taxes.

95

If You Need Money But Don't Want to Sell Stocks, Try This Idea

If you're an active investor who keeps your money working much of the time, there may be the odd occasion when you want some money but you don't want to sell your investments, because you naturally expect them to increase in value.

When that happens, you have an easy way to raise cash. Simply take the investments to a lender, lodge them as collateral and borrow money for a short period until you either don't need it any longer or until your investments look like they are topping out and can be sold.

If you don't like the idea of borrowing money, you have another alternative. If you have a self-directed RRSP you can always sell your personal investments to the RRSP and remove an equivalent amount of money from the plan. The assets inside your plan can be invested in a variety of ways including stocks, bonds, mortgages, term deposits and mutual funds. If you have one of those you simply arrange to sell it to your RRSP. You can do whatever you want with the cash after that.

If you sell at a profit you might trigger a capital gain in your name, but that shouldn't be a problem if you haven't exceeded the tax-free limits.

If you own a term deposit or GIC that won't mature for a couple of years, this can be the perfect way to get your hands on the money faster than normal. Simply sell the term deposit to your RRSP now. You get the cash while the term deposit remains in effect, but inside your RRSP.

Leverage Can Help Save Taxes and Create Wealth at the Same Time

Leveraged investments became almost a buzzword in the financial community as interest rates tumbled. But really, they aren't new at all.

Leveraging means borrowing money to invest. For must of us it's the only way we can buy our homes. We lodge a downpayment and borrow the lion's share of the cost of the property. Then we make monthly payments until the loan is paid off. In the meantime, though, we expect the value of the property to rise — not just the part that's paid for, but the entire value. As a result, we stand to make substantially more through owning a property this way than if we purchased only what we could pay cash for.

The same theory has proven successful in buying rental properties. If you pay cash for rental real estate, you'll earn more rental income than you have expenses to run the business. As a result, you'll have both positive rental income plus the expectation of a capital gain, which would be tax free under the $100,000 limit.

However, if you borrowed you could buy a much more expensive property. As a result, you'd be in position to reap a much bigger capital gain if the property rose in value. The "if" is not a very large one as real estate generally rises in value over a reasonable period of time.

In addition to the expectation of a larger than normal capital gain, you can also create immediate tax deductions. If the rental income is less than the cost of running the property, the excess

can be claimed as a deduction against all other forms of income. Recognizing this, many investors purposely borrow enough to make the property create a loss. They are in position to earn what could be tax-free capital gains, the tenants pay for much of the cost of ownership, and they get a "manufactured" tax deduction against their other forms of income.

97

Leveraging with Mutual Funds Can Be Easier than with Real Estate

In recent years the idea of combining leverage with the purchase of mutual funds has become quite popular. It's more convenient than leveraging rental real estate in that you don't have to spend time managing the money. It's handled by the portfolio manager while you will normally be the landlord when you buy real estate.

The vulnerability can and cannot be greater with mutual funds. They move in tandem with the stock markets. As a result, when stock prices fall, so too can mutual funds. If you've purchased them with borrowed money, your down payment can be wiped out very quickly.

However, when held for a reasonable period of time (five, seven, 10 years at least), leverage with mutual funds almost always pays off. For example: If you borrow to buy $50,000 worth of mutual funds and you pay 12% interest on your loan, you'll pay $6,000 a year interest. That interest is definitely still tax deductible. However, it must be claimed in a certain way thanks to tax reform. First of all it must be claimed against the interest income you earn. That's great because now that all interest is taxable this interest deduction will make our interest tax free.

The next thing we claim our interest expense against is our dividend income. Once again it is taxable. But, again we can make it tax free. In this case though we gain a tremendous advantage in that Canadian dividends from stocks and mutual funds qualify for the dividend tax credit. It is a tax-free rebate of taxes already paid or about to be paid. We get a double dip here in

that we've now made our dividends tax free *and* we also get a tax-free tax rebate.

The third income against which we must claim this interest expense is any capital gains we earn. That's great if we've already exceeded our $100,000 in tax-free capital gains as we now make any additional gains tax free. If, however, we have not yet triggered $100,000 in tax-free capital gains it appears that we now must offset these gains against our interest expense. Effectively, it appears that our capital gains are now taxable. It's not quite that bad, in that any capital gains offset in this way do not have to be used as part of our $100,000 in tax-free capital gains. In actual fact what that does is extend our tax-free capital gains beyond the $100,000 tax-free level. The gains we made were offset by interest expense. The new gains qualify for the $100,000 tax-free capital gains exemption.

What you've done is create a tax break similar to what you received when you borrowed to invest in rental real estate. A tax deduction on one hand plus tax-free income on the other — and the opportunity to earn substantially higher returns because you own more funds.

The bonus advantage is that mutual funds can be sold on a minute's notice any business day while real estate can be difficult to unload in a bad market.

Leveraging Will Save Taxes but Don't Let It Cost You Money

While leveraging real estate, mutual funds, the stock markets or any other investment can pay off handsomely, it must be done properly or it can cost you dearly.

First off, to make an investment loan tax deductible you must invest in something that pays a regular income *and* creates the possibility of earning a future profit. In other words, it can lose money now and for a reasonable period of time provided the investment produces some sort of regular income and the prospects of a profit some time in the future.

As a result, borrowing to buy gold or raw land or antiques that aren't used in business could be a mistake. The interest wouldn't be tax deductible. Yes, the gain would be a tax-free capital gain up to the normal limits, but the theory behind leveraging is to produce a tax deduction plus a tax-free gain.

The second problem can occur through misuse of leveraging. When you borrow money to invest it's great when the investment rises in value. However, if the investment loses value you can lose money faster than normal. As a result, you must be able to continue servicing your loans without selling off your portfolio. That means that entering into a leveraging program should only be done when you feel without much question that you can continue to pay the interest on your loans for a reasonable period of time.

That's easy to do. Simply compare your income to your expenses. Whatever income you have in excess of expenses that you think you'll have for a reasonable number of years, you can use to service a leverage loan.

That way, if the markets turn downward for a few months or

175

a year, you won't have to sell your investments. If you simply borrow hoping that the investment will service itself, you may have to sell some of the investment to service the loan right when the markets are bad.

99

Use the Three-Year Rule Properly

Many Canadians love to earn interest — and justifiably so. After all, we're conditioned to believe that our money is totally safe when it's on deposit at a financial institution — and it is. The problem, though, is that interest is taxable once we receive it. And if we try to compound it for a number of years, we still have to add it to our income every three years and pay tax on it even if we didn't collect the cash.

As harsh as that may seem, we may still be able to use that three-year rule to our advantage. You see, if you are really determined to earn interest income you can spread the incoming interest over whatever period of time you want, provided you bring in the right amounts within three years.

What that does, though, is give you time to buy tax shelters and plan your affairs properly so that the interest is claimed at the most beneficial time.

In the past we used to be able to earn up to $1,000 a year in tax-free interest income. At least we used to be able to pocket some tax free and then compound the rest for a longer period of time. Now though, that privilege has been lost as all interest is taxable in the year it is earned — even though we may not actually receive it.

Once you understand that all interest is taxable you can understand the value of compounding. If you invest $1,000 at 10% you will earn $100 a year. If you accept the money each year you get to keep about $65 after tax to reinvest each year. However, if you compound the $1,000, the yearly interest of $100 is considered tax free for three years. In the first year you get to reinvest $1,100 rather than $1,065. In the second year it's $1,210

compared to $1,134. You have your money plus the taxman's share working for you for that three-year period.

Because you know a chunk of money is going to arrive on your tax return three years from now, you can begin your smart financial planning between now and then to make sure that your tax bill is at a low at that time.

You might want to buy a movie, a flow-through share or a limited partnership that will produce substantial tax relief just when the interest is going to materialize. That way you'd have long-term compounding — and then a chunk of interest that would also be tax free because it was offset by a major tax deduction. In fact, there are investors who make a good living manipulating the three-year rule in this way. They may, in fact, buy three-year compounding investments this year, two-year investments next year, and a one-year investment in the third year. As a result, all their interest income arrives every three years. That year they buy a tax shelter that creates a large deduction that offsets all the accumulated interest.

Another time the three-year rule can be used productively involves those who are about to retire, take a sabbatical, or lose a job. They know that their income will fall two or three years from now, so they lock all their investments away until then. As a result, all the income comes due when they are in a low tax bracket, with a small tax obligation.

In fact, pensioners can do even better. They can roll any part or all of their pension into an RRSP. That wipes out their pension income so they will have little tax liability when they bring three year's worth of accumulated interest into their names. So you see, while the three-year rule can be a problem, it can also be a benefit.

100

If You Really Want to Earn Interest, Try This Tax-Saving Idea

Tax-free income's a lot better than taxable income in my view. Naturally, the yield is important too, but that's why we always compare after-tax yields to see which investment is better for us.

Term deposits and Canada Savings Bonds normally pay set rates of return. The stock markets and other volatile investments don't always guarantee any rate of return but they may pay off many times over when you hit them right.

There is a combination of the two, though, that may be attractive for some investors. There are bonds traded by stock brokers that pay less than the going rate and as a result trade at a discount to the market. In very simple terms, that means that you earn something like the savings account rate but you only have to pay a portion of the face value of the bond. However, when that bond matures a year, two or 10 or so down the road, you are guaranteed to receive the full face value of the bond.

You paid 80 cents on the dollar, let's say, but you get back 100 cents on the dollar, plus you've been earning interest as long as you held the bond.

The advantage, of course, is that the 20 cents on the dollar increase is treated as a capital gain — as long as you don't exceed $100,000 in your lifetime. It's a nice way to combine the safety of bonds with some capital gains advantages. By the way, don't worry about interest rates rising. You're always guaranteed the face value on the maturity date.

101

If You Don't Need the Regular Income, Don't Take It

Too often our desire for a physical display of success costs us tax dollars.

Canadians are notorious for earning interest income. We like to buy things like term deposits, guaranteed investment certificates and Canada Savings Bonds because they produce a regular income. But don't forget that all interest is taxable. That's why it's better to seek out dividends or capital gains. We can earn as much as $22,000 a year in tax-free Canadian dividends and up to $100,000 in tax-free capital gains. Knowing this, those Canadians who earn interest should look at switching to Canadian dividend-paying stocks or mutual funds to produce tax-free dividend income. Or they should give some serious thought to buying things that will appreciate in value.

A principal residence is a classic choice. If you rent you pay for the property for the landlord. If you buy your own house you have to commit yourself to monthly mortgage payments, utilities and maintenance. However, you at least know that the property will rise in value tax free in your own name.

Rather than having to claim the interest as taxable income each year, you'll own investments that will rise in value tax free as long as you own them. When you sell them there may be a tax problem, but that's only *if* you sell them.

If You Really Want to Save Tax, Don't Earn Interest Income

One reason why so many Canadians pay more tax than necessary is that they choose to earn too much interest income. They like the idea of having a regular income every year or the ability to see their yield, then compound it.

The problem, though, is that when we earn interest that interest is taxable, either every year or at least every three years. However, if we buy assets that produce no income, but instead simply rise in value, we'll never have to pay tax until we sell the investment. Then we'll trigger a capital gain.

For example: If we buy a piece of raw land, that land will rise in value completely tax free until we sell it. We don't have to pay any tax each year or every three years. All our money compounds until we sell. In fact, the same theory applies to art, antiques, real estate, stocks and mutual funds. They can all rise in value completely tax free until they are sold.

Under present legislation we may not even have to pay tax when we sell these investments. The first $100,000 worth of capital gains is tax free. That means we subtract our purchase price from the price we receive when we sell and the first $100,000 is tax free. When we calculate the purchase price it's important that we add on any costs to complete the transaction, such as commissions. And, when we calculate the selling price it's important we consider only the net, in-pocket, after-expense proceeds.

In addition, don't forget that when we invest in small businesses and operating farms that as much as $500,000 in capital gains can be tax free. As a result, picking the right investment can produce substantially more tax-free income than normal.

Once we exceed the $100,000 or $500,000 limits we can still

prosper by choosing investments that rise in value rather than produce a regular income. Under existing legislation no more than 75% of capital gains can be considered taxable income. Once we become taxable, 100% of salary attracts tax. When we earn interest income it is totally taxable and even dividends must be added to our income before we get to use the dividend tax credit. When it comes to capital gains at least one-quarter will be tax free with only three-quarters taxable. As a result, capital gains remain one of the lowest-taxed types of income we can earn.

103

Swapping Dividends Can Save Taxes

There's a substantial advantage to earning dividends from Canadian companies. The dividend tax credit wipes out most of the tax bill. In fact, for many taxpayers it allows them to earn up to $22,000 in tax-free investment income.

The problem, though, is that the dividend tax credit isn't a tax deduction. It's a rebate of taxes that you've already paid or a waiving of taxes that you were going to pay. But if you don't owe any taxes, how can you use a credit? And, if you didn't pay any taxes, how can you get them back?

Well, that's the dilemma that some taxpayers face. They may not have enough income to be able to fully use the dividend tax credit. In that case, they have two choices: one is to sell the stocks and buy term-deposit-type investments. The other — and the better choice in my mind — is to look at transferring your dividends and the dividend tax credit to your spouse's tax return.

If your spouse would have been able to claim you as a dependant had you not received these dividends, you have that option. Your spouse would now be able to claim you as a dependant exemption and will be able to use the dividend tax credit to wipe out tax on his or her tax return.

Make sure you do all the paperwork, though, as you don't always win by making this switch.

And make sure you transfer all the Canadian dividends. When you use this option you have to transfer them all, or none at all.

Tax Rates Are Marginal

Many taxpayers make a serious mistake when they think about their tax bills. They think in terms of their average rate. That is, I earned $35,000 and paid $8,000 in tax. As a result, I'm in the 22% tax bracket.

In actual fact, though, that's not the way it works. In fact, if you think that way you're probably going to end up paying more tax than you should. If you think you're in a low tax bracket you won't take as much advantage of tax-saving ideas as you should.

Prior to tax reform we had 10 different levels of federal tax. Under tax reform that's been reduced to only three. Each time we move to a new tax bracket all the income we earn from that point on will be taxed at that new higher rate. When we had 10 tax brackets the pain wasn't as great when we moved from bracket to bracket. But, now that there are only three, the tax rate increase each time we move to a higher bracket is substantial.

It isn't your total income that's important. The proper use of tax deductions can lower it substantially. As a result, it's taxable income that determines your tax bracket. The higher your taxable income the greater your tax bracket.

For example: If you earn $27,500 or less per year you are in the 17% marginal tax bracket. Provincial taxes will be added to the 17% (around 50% of the federal tax in most provinces). As a result, you will actually pay about 26% income tax on your earnings. Don't forget, though, that you will have used your personal deductions and exemptions so your average tax rate will not be 26%. But that's not the important point. The important point is that each additional dollar you earn will be taxed at 26%.

Even worse is the penalty you pay when you move to the next bracket. If you earn $27,500 in taxable income you pay 26% tax

on your last dollar. However, when you earn $27,501 you will pay approximately 39 cents tax on that dollar. That's why it's so important to know your tax bracket rather than thinking about your average tax rate. In fact, a taxpayer who earned $27,500 in total income may pay no tax because of the proper use of tax deductions.

Once you exceed $55,000 in taxable income you are in the 29% federal tax bracket. When the provincial tax rates are added on taxpayers will be paying a low of 42.92% in the Yukon to a high of 51.09% in Quebec. Ontario taxpayers will pay 44.66% while those in Alberta will pay 44.93% on each dollar earned above this level.

Here's the real problem. The early dollars are taxed at a low rate. As a result, it appears that our tax rate is low — and it is. What counts, though, is the rate of tax we pay on each additional dollar. After all, we want to better ourselves. But, when we do, we have to remember that all those raises we get will be taxed at a much higher rate than our average tax rate. In fact, in many calculations it looks like you are paying 20% tax based on your average but you are actually paying close to twice as much.

In the past we used to recommend that taxpayers get out the previous years' tax returns to determine the rate they paid on their top dollar. It's more difficult to do this under tax reform as many tax deductions have been replaced by tax credits. However, when you realize that we continue to run a substantial government deficit you know that real tax rates have not declined. They've only been changed to make it appear so. Comparing your top marginal tax rates of previous years can still give you a good idea of how much tax you are paying on your top dollar.

To do that simply go to last year's tax return and look for the taxable income line and compare it to the new tax schedules under tax reform. Then all you have to do is add on the provincial tax percentages which average around 50% of your federal tax bill. Provincial surtaxes will increase your tax bill so if you are going to err, do it on the high side.

Under tax reform we've been led to believe that we will have

lower tax rates. And we will. But that doesn't mean our tax bills will be lower. What it really means is that we should find out for ourselves. Doing it before the end of each year will help us determine whether we should be manufacturing some tax relief to lower our tax brackets.

105

Limited Partnerships Limit Liability but Maximize Tax Savings

If you want sizable tax savings, give some thought to one of the more sophisticated tax shelters. Generally, they're only for the higher-income groups but there are occasions when they can help others as well.

A limited partnership is a share of an ongoing business. Normally, it's one that's just starting, but there are occasions when an existing business may be syndicated in a limited partnership format.

The advantages? Well, that's an easy one. You get extra-large tax deductions in the early years. Let's say this tax shelter is a hotel that's presently under construction. The investor buys shares in this development well before the construction is completed. That means there's little chance to generate any income for the couple of years in which the building is under construction. At the same time the business is in the process of building this hotel it's going to incur some sizable expenses: interest on borrowed money, operating expenses, depreciation. All of these expenses can be passed through to the investor. Those expenses can be used to lower tax on any forms of income the investor earns. That saves substantial tax dollars in the early years.

Once the building is completed, it's hoped that it will be profitable and produce positive investment income. And the taxman has paid for much of the cost of this investment.

106

Limited Partnerships Can Help Get Money Out of an RRSP Tax Free

While we normally think of a limited-partnership-type tax shelter as most useful for high-income groups, it can be very useful in other special cases.

One example occurs when an individual in the middle-income bracket wants to remove a chunk of money from an RRSP. We know that money removed from an RRSP must be added to our income and taxed at our marginal tax rate (the highest level we qualify for). As a result, we may not want to remove this money. However, if we could create a tax deduction that would offset the money coming out of our RRSP we'd effectively eliminate the tax bill.

One recent limited partnership vehicle comes to mind. It produced a $28,000 tax deduction in the first year. As a result, the investor would be able to remove $28,000 from his or her RRSP without paying any tax on it. In the first five years, in fact, there was enough offsetting tax relief that the investor would be able to remove $87,000 from an RRSP totally tax free.

In doing so the money would not only come out tax free but would be used to pay for shares in an ongoing limited partnership which would eventually provide a decent rate of return as long as the investor continued to own it.

In addition, once the business is doing well share values should rise. Selling them would create a capital gain that could be within the tax-free limit.

What you've accomplished, then, is to save a chunk of taxes on your RRSP withdrawal and use them to buy what could be a tax-free capital gain.

107

How To Declare Capital Gains to Your Best Advantage

Sometimes I hear people say, "Why should I bother to declare any capital gains I earned? I mean, they're tax free so why go through the paperwork of declaring them on my tax return?" The thinking is right, I guess, in that all we are really doing when we declare our gains is doing the paperwork for Revenue Canada. We must declare our capital gains on page 1 of our tax returns and then remove them on page 2. As a result, they end up being tax free until we exceed $100,000 worth of normal capital gains or $500,000 worth of capital gains created by selling a farm. On our 1988 tax return (to be filed early in 1989) we will also be able to claim up to $500,000 in tax-free gains from selling a small business.

The real reason why we *must* declare our capital gains is to help Revenue Canada know when we exceed our tax-free limits. Many think they'll never be so lucky. But you'd be surprised how quickly you can get there. A couple of real estate transactions, a killing in the stock markets or mutual funds and you're there. And Revenue Canada wants its share as soon as we pass the tax-free limits.

Revenue Canada can also use this information to tax us earlier than normal. For example, if you created your capital gains in the wrong order you could pay dearly. The first $100,000 worth of gains we report will be credited toward the $100,000 of ordinary tax-free capital gains, no matter how they were earned. That means that selling a farm that created $100,000 worth of capital gains would create a tax-free gain, but we wouldn't be able to earn any other tax-free capital gains. If you were in this position you could benefit by selling all your stocks and mutual funds

before closing your farm deal. The stock or mutual-fund gains would be tax free as ordinary gains and the farm gains would be tax free as part of the remaining $400,000 of farm or small-business capital gains. When we declare our gains we have to declare the date of the transaction, which will give Revenue Canada the ability to cross-reference our gains and maybe levy extra tax.

When we declare a stock-market or mutual-fund gain we give the purchase price and sale price. As a result, it's pretty easy to cross-reference these items. When it comes to real estate, though, it's not quite as easy. If the property has been owned for a long time it may be difficult to justify the original value for tax purposes. And, there are cases where Revenue Canada feels the property was sold for less than market value. As a result, they may reassess the capital gain declared.

Why would somebody sell at less than market value? Well, there may have been several properties involved, one of them a tax-free principal residence the value of which was inflated so the taxable property could be reported as generating a small gain.

Another more costly revelation could be the reassessment of capital gains as normal income and, as a result, fully taxable income. An individual who actively buys and sells real estate can be considered a professional. They may buy a property, renovate it and sell it at a nice profit. The profit was created, though, by the renovation. Revenue Canada, in many cases, will consider this as earned income similar to a salary. As a result, it will be fully taxable. Revenue Canada will definitely be looking for taxpayers who report a number of different transactions on their tax returns.

There are other reasons why Revenue Canada wants us to report our capital gains that may not seem as important, but can whittle away at our take-home paycheques. While capital gains can be tax free they can also trigger the alternative minimum tax. As a result, part of our gains could become taxable. While being able to claim the capital-gains deduction on page 2 of our returns appears to make capital gains tax free, the inclusion of the income

can eliminate other tax benefits. The net income line determines whether we can claim a relative as a dependant exemption. If that relative claimed capital gains he or she could be eroded or eliminated as a tax exemption. In addition, it's our net income that determines whether or not we can claim the child tax credit or the federal sales tax credit. Claiming capital gains once again could cost us taxes indirectly.

It would be so much easier if we didn't have to claim our capital gains until we exceeded the tax-free levels. However, it's obvious why Revenue Canada wants us to claim them each year. We do their paperwork for them and they stand to gain revenue in other ways.

By the way, if you think it's not worth doing the paperwork consider this. If Revenue Canada finds that we didn't declare our tax-free capital gains they have the power to deny us the entire tax-free capital gains limits.

108

Don't Forget to Claim Capital Losses

For some reason taxpayers have come to believe that capital losses are no longer tax deductible. I guess it has to do with tax-free capital gains. Once we were offered one-half-million dollars in tax-free capital gains we were led to believe that losses were no longer useful. However, now that the half-million has been slashed to $100,000, except for operating farms and small businesses, we should give very serious thought to calculating capital losses. They can be very helpful in extending the tax-free capital gains limit well past the advertised levels.

Here's what I mean. If you earn $100,000 in capital gains you don't have to worry about normal income taxes. I say normal as capital gains in this example are free of ordinary income taxes. However, there is something called the alternative minimum tax that can indeed create a tax problem when you earn large capital gains on top of your other income. If the amounts are small, by the way, you probably don't have to worry about the AMT.

Those who earn a large capital gain in one year will have to worry about this tax though, so they may want to consider triggering capital losses. The losses will offset the capital gains so it doesn't appear that you earned as large a capital gain when it comes time to calculate the AMT.

The next problem is when you earn more than $100,000 in capital gains. Then you have to pay tax on two-thirds to three-quarters of the gain at your normal tax rate. In that case it's easy to understand the value of capital losses. All you have to do is sell your losers to manufacture losses that offset your gains.

Now, in some cases that might seem unreasonable in that these clunkers may, if only in your own mind, have the potential to

make you a millionaire sometime in the future. You bought them to make money. Why would you want to dump them before you did? Well, don't worry. We can manufacture some tax relief and still own these future winners. All you have to do is sell them at a loss and buy them back again later. Now, their new purchase price, while the same as the selling price, is lower than the original purchase price. When they do rise in value you'll have to claim the gains as capital gains. But that will be some time in the future and you've already used the losses to save taxes by offsetting capital gains. In addition, we can always hope that by that time there will be new rules that will make these capital gains tax free or at least taxed at a lower rate.

Most people feel they will never make it to $100,000 or $500,000 in capital gains. But, who knows? You could always win the lottery and be loaded with investable cash. Or, all you need is a good long-term purchase program and your money will be constantly in place to produce profits. And, what if you inherit some money or the family cottage? Believe me it doesn't take long to produce enough capital gains to be taxable either as a taxable capital gain or as part of the alternative minimum tax.

For example, what if you have a $20,000 capital gain. Yes, you may not feel it is taxable but you still have to claim it on your tax return as a gain. That may affect other tax calculations or the AMT. If, at the same time, you could trigger $10,000 in capital losses you could lower your real capital gains to only $10,000. That might help you tax-wise.

You may also want to think ahead. Under tax reform the amount of our capital gains that must be used in our calculations gradually escalated from 50% to 66.33% to 75%. If you fear that the percentages may rise you may want to trigger capital gains and losses sooner. If you feel that the percentage of taxable gains will fall you have more incentive to trigger capital losses now to offset your capital gains.

It's also imperative that you look to the future when you consider capital losses. We've gone through a very confusing period of tax changes. Who knows how long we'll even be able to claim

any tax-free capital gains or be able to offset our taxable gains with capital losses? If you have even the slightest fear I'd always trigger capital gains when the investment merited it and capital losses when it was best.

When You Earn a Tax-Free Capital Gain, You Can also Earn Other Income

While earning a pure capital gain will save taxes, it doesn't produce much of a yearly income. That's why it's generally better to combine capital gains with other investments.

For example: Rental real estate. If you buy a duplex or triplex, you'll own an investment that can rise in value totally free of tax. In addition, though, you'll have somebody paying part of the cost of owning this property — the tenants.

There are other examples to consider as well — a mutual fund for one. When you buy a mutual fund you group your money together with that of other investors. The portfolio manager then has enough money to buy and sell shares in a large group of companies rather than limiting your exposure to only a few. If the fund earns a capital gain it will pass it on to the investors. In addition, the fund may own shares that produce dividends. Those dividends can be passed on to the investors as well. If they're Canadian, they will qualify for the dividend tax credit that allows many Canadians to earn as much as $22,000 a year in tax-free dividends. In addition, the mutual fund may also produce interest income and if the value of the units themselves rises, they also can be sold at a capital gain. In effect, then, you end up with a double chance for a tax-free capital gain plus virtually tax-free dividends plus some interest. But at least the interest is kept to a minimum.

Another example is a stock portfolio. If you buy good quality stocks with a good record of paying dividends, you'll be in posi-

tion to earn a tax-free capital gain at the same time as you receive dividend income.

One major advantage to this type of investing is that you have income coming in to help you survive the downturns in the markets. In addition, because you have both a regular income and the prospects of a future profit, Revenue Canada is prepared to let you claim interest on loans taken to help you buy these investments as a tax deduction.

An Illness, as Sad as It May Be, May Save Taxes

Medical expenses are tax deductible under tax reform but only when handled properly. The first consideration is that there's no longer an automatic 3% of net-income threshold level. Before tax reform we could only claim our medical expenses as tax deductions when they exceeded 3% of our net income. As a result, the higher your income the tougher it was to create any tax deductions through claiming medical expenses. Under tax reform it appeared at first that it was going to be even more difficult to claim medical expenses because our net incomes were going to rise as some tax deductions that previously came before the net-income line were shifted to later positions in the tax return. However, Revenue Canada has included an "either/or" offer. We can use the lesser of 3% of our net income or $1,500 when calculating our medical expenses. As a result, it's generally easier to claim medical expenses in the name of the spouse who earns less than $50,000 in net income. They will be able to claim their medical expenses faster as their threshold level will be less than $1,500.

In Revenue Canada's eyes husband and wife are one when it comes to medical expenses. As a result spouses can combine their medical expenses at tax time. If there are children involved, though, they cannot automatically be included. The only way a child's medical expenses can be claimed by a parent is to claim the child as a dependant tax credit on that parent's tax return. And, under tax reform Revenue Canada generally expects the higher-income spouse to claim the children as tax credits.

As a result, this year families are going to have to do a little extra tax planning when it comes to claiming medical expenses.

For two-income families where no children are involved it's still worthwhile to try to claim the medical expenses in the lower-income spouse's name. Approximately 26% of these medical expenses will be treated as a tax credit no matter which spouse's name is used. However, by claiming in the lower-income spouse's name the medical expenses will be tax deductible sooner provided the lower-income spouse's net income is lower than $50,000.

When children are involved it is beneficial to attempt to claim the child who experienced these medical expenses as a dependant of the parent who will benefit most when it comes time to claim the family medical expenses. As a result, they will become tax deductible sooner. However, it should be remembered that the taxman wants us to claim the family allowance cheque in the name of the higher-income spouse.

It's also possible to juggle medical expenses incurred in different years on to one tax return. While we normally think of medical expenses on a year-to-year basis there is an advantage to overlapping back-to-back years. You see, Revenue Canada allows us to claim medical expenses in a yearly or 12-month period as long as the 12 months end in the taxation year. That means that an individual or family that incurred some substantial medical expenses in overlapping years may be able to lump those expenses into one tax year.

Here's what you want to do. Look at your medical bills over the past year. If you find that they generally occur on a month-to-month basis you will probably want to stick with the normal yearly calculation. However, if you find that you incurred some substantial medical expenses partway through the year you should consider claiming on a 12-month period rather than on a calendar-year basis.

The problem with the calendar-year basis is that each year you must exceed $1,500 or an amount equal to 3% of your net income in expenses before you can claim any medical bills as a tax deduction. If you were able to merge your medical bills from the last half of one year and the first half of the next, let's say, you would be able to claim the bulk of two years' worth of expenses

with only one threshold level. For example, if you had $1,500 a year in medical expenses you may get no tax relief because of the threshold level. However, if you could lump those bills together you would be able to claim $3,000 worth of medical bills in one year. The first $1,500 wouldn't be tax deductible but the second $1,500 would be.

Using this theory you'll find it beneficial to keep a running total of your medical bills. At certain times you'll find it's beneficial to have elective medical work done. You may have dental work done because it is now tax deductible or get new eyeglasses or have other work done because the taxman will pick up part of the cost.

111

Win a Lottery? Take the Money Properly

Few people win the lottery, even the small prizes. But if you're lucky enough to hold a big winning ticket, make sure you take the prize properly.

Sometimes individuals share tickets so they have a number of prize-winning opportunities. In that case the prizes are legitimately split between the subscribing partners. In other cases families will buy tickets between themselves with the prizes being split based on the amount contributed by each spouse. In the case of a husband and wife — or children for that matter — this opens the door to some possible tax savings.

Let's say you win a large prize — say $100,000 or so. Normally a husband and wife would split it down the middle. In fact, property rights suggest they wouldn't have much choice. But upon assessing a family's financial situation you might find it better to have one spouse collect all the money.

One circumstance would be when one spouse already has most of the family's assets in his or her name. There are many families where only one spouse has worked. As a result, the pension, the RRSPs, the investments, etc. are all lumped in one spouse's name. What better chance to legitimately accumulate a chunk of money in the other spouse's name. Most of the winnings will be invested, so if the money is split evenly, the working spouse will see his or her tax bill rise. If the money is aimed at the lower-income spouse, any investment earnings will be taxed at a lower rate. So make sure you accept lottery winnings properly.

112

When Santa Has Financial Smarts

So, here it is almost Christmas time and you're struggling to find those last-minute gifts that you need. Well, why not think financial? No, not cost — make the theme something that will eventually create wealth, large or small, for the recipient.

For example, have you considered giving a subscription to one of the excellent money-type magazines that are available? *Financial Post Moneywise Magazine, Canadian Business* and *Vista* are several that come to mind that offer excellent, down-to-earth, money-saving ideas for most sectors of the population.

Or, what about a subscription to a newspaper with a good business section? It could be your local newspaper, a regional one, or a totally business-oriented publication like *The Financial Post* or *Financial Times*. The recipient may actually find enough investment tips and tax-saving ideas that the subscription price will be saved many times over. In addition, there are several more in-depth publications that could prove valuable. *The Wall Street Journal* is one that comes to mind.

Another choice is a subscription to one of the monthly newsletters that have become so popular in the last few years. The advantage here, of course, is that you can pick one that zeroes in on the area of expertise that most appeals to your recipient. You can pick financial planning, the stock market, real estate, international finance — almost anything you want.

If you're not excited by any of these financial ideas you might go further and offer the real thing — a paid-for session with a financial consultant. The cost will vary with the length of the meeting so make sure you determine how long it will last. Here though, you have even more flexibility in that you can pick a financial planner who is involved in a specific area.

Business-type books have been amongst the most popular in recent years. And this year is no exception with a long list of new editions. There are books on small business, the future of the economy, stock markets, mutual funds and personal financial planning. Personally, I prefer the latter — not because it's my type of writing, but because they help individuals learn to manage their own money. That will save them money and taxes in future years. As a result, a gift like like this could be used and remembered for many years in the future.

What about giving a specific investment? Canada Savings Bonds would appear to be the natural as they can be purchased in small amounts and are virtually risk free. Unfortunately, though, they require some foresight as they are only on sale in the fall. You might want to consider some CSBs as gifts next fall — well in advance of the Christmas season.

More sophisticated investments could also prove valuable as Christmas gifts, especially for children, as they may encourage them to think financially well ahead of schedule. Mutual funds and stocks may not sound terribly attractive after a stock market sell-off. However, history has proven that the best managed, the conservative, the blue chip stocks and mutual funds will outperform most other investments over a reasonable period of time. Funds like Templeton Growth, Industrial Growth, United Funds, Cundill Value, Trimark and other well-established funds historically yield 15% and 25% per year. The younger the person you give them to, the greater the likelihood the funds will pay off.

The same theory applies to stocks. Buy something that has long-term potential. In fact, that might be the perfect gift for a youngster — some shares in a small company that might explode to be worth a ton of money down the road. Examples would include shares in a junior gold mine like Flanagan McAdam or in a young venture capital company like Mintron. Listed on the Alberta Exchange, it's rumored to have invented a small lightweight engine that can fly an airplane. Time is on your side with small companies that have large potential.

For children, there's an especially attractive stock issue. They

like toys. They break toys. Why not give them shares of a toy company like Irwin Toy? They profit as toy sales improve, and they also get to join Irwin's junior shareholders club. Once members, they are invited to the annual meeting where they get a preview of all the new toys for the coming year and even get one to take home as an extra dividend.

And don't forget gold and other precious metals. Coins and gold wafers are especially interesting in that they can be converted into jewelry that may well rise in value in future years — a gift that appreciates in value, not one that is soon forgotten.

113

What Does the Future Hold for Tax Rates?

"Why bother contributing to an RRSP when I'll only pay more tax when I remove the money than I saved when I contributed it? After all, tax rates have a habit of rising over time — and if I'm any good my salary will rise in future years." That's the question I received in a recent letter.

Quite frankly, this writer isn't the only taxpayer who feels this way. And I suppose there may be a few who actually will fall into this position. But, for most taxpayers the opposite is the case — they will pay lower tax rates when they remove the money from their RRSPs than they saved when they originally made the contributions.

In addition, don't forget that the tax-free compounding available inside an RRSP will give you much more money down the road. Even if the tax rates were higher, the much bigger pot of money will produce more after-tax income.

The real question is this — will the tax rates be higher in coming years?

Well, we know that the government is committed to lowering marginal tax rates. The first step was to introduce the present version of tax reform. But, the next step will be the introduction of a national sales tax — and an accompanying reduction in marginal tax rates once again. That will come before the next election, and it is clear that the Conservatives will follow the present plan.

Recognizing that eventuality, we can do some future planning. The maximum tax rate in 1987 was around 53%. For 1988 it fell to the 44% to 46% range. Moving money from 1987 to 1988, then, was an attractive tax planning tactic. However, the same theories can provide even more benefit over the long term.

Check the tax rates in some of the American states. In Florida and many other states the maximum federal and state tax bill is 28%. That's so much lower than Canadian rates that Ottawa can't help but worry that Canadians will hide money in the American states where tax rates are that low. In fact, the classic case has the self-employed, small-business type buying the goods that he or she sells through an American company that they own. They simply mark up the price they pay so there's little profit recorded in Canada and all kinds of profits reported in the U.S. where tax bills are lower. Their expenses will, naturally, be reported in Canada where the tax relief would produce the biggest savings.

Ottawa recognizes this can and will happen. As a result, they know they must lower our tax rates further. At the same time they know they can't lower our tax bills because they still have a substantial budget deficit. That's where the changes in sales taxes will hit us. They plan to increase sales-tax rates at the same time as they reduce marginal tax rates. It will take some time but I think our maximum marginal tax rates can fall to the 36% range in another four or five years.

Given that, there's no question that we should clearly take every tax deduction we can find right now so we will save taxes at today's tax rates. If we leave the money inside our RRSP for four or five years we should be able to remove it at a much lower tax rate.

In past years there's no question that saving taxes then didn't guarantee that we'd repay them at a lower rate down the road. Yes, the faster compounding inside a tax-free environment made an RRSP very attractive. Now, though, the virtual guarantee that tax rates will fall in coming years makes an RRSP a four- to five-year plan, not a lifetime program. Naturally, it's also better to look much further down the road. Beginning this year, all interest is fully taxable. That means long-term compounding is very valuable. If you can put your money into a long-term investment you will be able to compound both your principal and interest plus the normal share of the interest that would have gone to the

taxman. As a result you have much more to work with down the road.

Sure, it's easy to say that registered retirement savings plans are valuable as short-term tax-saving devices, but the real value is long-term compounding. The tax rebates gained can be used for whatever purpose you choose while the money inside can be compounded for as long as you wish, rather than only three years outside the plan.

The key is don't ignore these plans because you aren't interested in long-term investments. Take the tax relief first. In almost all cases the money can be removed at a lower tax rate. It just takes a little planning.

114

Looking Forward to Tax Savings

The present forward-averaging provisions appear to offer very little tax relief compared to the benefits previously available through general averaging. However, forward-averaging can still be useful.

For example, if you know your financial situation is going to change dramatically in coming years, you might be able to save taxes using forward averaging. Let's say you're planning to retire in the next few years. You can generally count on a reduced income from then on. In addition, you may qualify for the senior's exemption, the $1,000 pension income deduction, RRSPS and other tax-saving ideas. That can give you a pretty secure feeling that you'll be in a lower tax bracket when you finally retire.

If so, give some thought to using forward averaging now when you're in a high tax bracket. You can recall the money in your retirement years and pay a lower tax rate at that time.

The same theory is extremely useful for taxpayers who are prepared to invest properly. If you know your income is abnormally high and will fall in coming years because you have plans to invest in some tax shelters, you could profit by claiming forward averaging now and then recalling the income in the years when your income is going to be substantially lower because you're using the tax deductions that accompany your tax shelters.

There's also a belief that tax rates will fall in coming years. All the more reason for those in the higher-income brackets to forward average to years when rates will be lower.

115

Year-End Tax Tips

As this first year of tax reform winds down it's imperative that we seek out every form of tax assistance we can. Remember, we've lost the $1,000 tax-free investment income deduction. In addition, other deductions have been cancelled or reduced. As a result, our taxable income will generally be higher this year. And, while the percentage of tax we pay will be lower, it's vitally important that we reduce our taxable income.

It's also important that we defer as much income as possible to future years. We believe that the introduction of Phase II of tax reform will mean substantially lower income-tax rates. At the same time more tax deductions will be eliminated. The loss in revenues will be replaced by the introduction of a national sales tax.

If you subscribe to this theory there are definitely some things you can do to protect yourself and even win in the future. The first is to switch out of interest income to dividends, capital gains, rental income or a combination of the three. Dividends qualify for the dividend tax credit which allows us to earn as much as $22,000 a year in tax-free investment income. Capital gains allow as much as $100,000 in a lifetime. Real estate income can be offset by capital cost allowance thereby deferring the tax to future years and it's the only type of investment income that qualifies for contribution to an RRSP.

It's also important to defer income to future years when tax rates will be lower. For example, if you are determined to own term deposits and guaranteed investment certificates it's best to compound them for at least three years. The rate is higher the longer you leave your money with the institution and the tax break is better. We don't have to pay tax if we don't actually

receive the money, except when we own compounding invest-
ments. In that case we can compound them for three years before
we have to pay tax. It appears that it would be wise to compound
investments for at least three years for several reasons. The yield
is usually higher, the full earnings are compounded each year
rather than only the after-tax amount invested — and we believe
there's a chance that the lower tax rates that will come with Phase
II will be in place three or four years down the road.

It's also valuable to contribute the absolute maximum to your
registered retirement savings plan before year end. In the past
there were worries that we'd have to pay a higher tax rate to
remove the money than we saved when we contributed it. That's
no longer a major fear as in most cases the tax rates will be lower
once Phase II is in place.

This is a big time of the year for tax shelters. Everybody seems
to have one. When it comes to choosing a tax shelter it's important
to make sure it gives you tax relief for a few years and not just
for one. In addition, it's imperative that you be able to get out
of it in at least five years. That way you can manufacture tax
deductions at today's higher tax rates and recapture or pay capital-
gains taxes when you sell at lower rates.

Those who have not yet reached their $100,000 limit in tax-
free capital gains may want to trigger some capital gains this year
or next. These decisions are not purely tax driven. That is, if an
investment has great future potential, you shouldn't normally
consider unloading it simply for tax purposes. Conversely, if an
investment looks like it's going to fall apart you should get rid
of it regardless of your tax situation. The value to manufacturing
capital gains this year or next has to do with changes in the
capital-gains tax rules. This year and next, two-thirds of the gains
must be used when calculating capital gains. Beginning in 1990
three-quarters must be included.

The opposite generally applies when it comes time to trigger
capital losses. Generally, it's better to wait until 1990 to trigger
capital losses. At that time 75% of them will be tax deductible
against other capital gains.

Thanks to something called CNIL (cumulative net investment losses) we have to carry forward investment losses that have been claimed against income other than investment income. That can delay triggering tax-free capital gains. If you have some losses this year you may want to buy some high-yielding, dividend-paying stocks just before year end. The dividends will be payable this year, offsetting CNIL, but you will also be able to save taxes by claiming the dividend tax credit.

Finally, if you are a pensioner you have two key considerations. If you turned 71 this year you must arrange to eliminate your RRSPs by year end. We recommend an RRIF. And, if you haven't been making your quarterly instalments on time you should do it right away.

For self-employeds and business types manufacturing last-minute relief is easier than it is for employees. They can buy equipment and supplies that won't actually be used until next year. They can buy a new vehicle, prepay some of the expenses that might not normally have been paid until the next month or even pay a bonus or two to key employees, like a spouse.

For most taxpayers, though, it's not quite so easy.

Before tax reform it was popular to marry just before year end. You could claim your spouse as a full tax deduction even though you were only married for days or hours. That's no longer possible so marrying right now should be for love, not tax relief. Having a child before year end, though, can be very useful. You get the full dependant credit even though the child is only days or hours old, you get one month's baby bonus cheque (you must apply for it), and you qualify for the full child tax credit which is completely free of tax. While it's a little late to start planning this strategy for this year those with children due right around the year end would be better off giving birth on New Year's Eve rather than New Year's Day. You get a sure thing rather than a possible chance at the ''first baby of the year'' gifts.

Giving to charity at this time of year can be more rewarding than in the past thanks to tax reform. When we contribute less than $250 to charities we qualify for a tax credit of about 26%

of the money we contribute. However, once we exceed $250 we instantly jump up to the maximum tax level — the level at which the richest Canadians are taxed. Nobody wants to be taxed at that rate but it sure is nice to get tax deductions at that level. Effectively, then, once you exceed $250 in charitable contributions you will get back about 47% of the monies you contribute regardless of your tax bracket.

High-income Canadians aren't nearly as excited about this change as are lower-income types. Those with money got more money back last year because they were in even higher tax brackets. For lower- and middle-income taxpayers, though, it's great. They get back almost half what they donate.

Don't forget that it's not necessary to give money to get this tax relief. You can give investments, art, antiques, life insurance policies, etc. in many cases and get similar tax relief.

You should be talking to your family members before the year winds down. A spouse can earn $500 in net income before being lost or diminished as a tax deduction. Children can earn $2,500 or so. But, "net income" is the key in this case. There are many deductions that come before the net-income line on our tax returns; things such as tuition, pension contributions and registered retirement savings plans. That's why it's so important to look at a dependant's income before year end as you may be able to bring that dependant back on side as a full dependant simply by doing some tax planning in their name rather than your own. And, the tax savings are often at your tax rate not theirs.

For example: If your spouse earned $1,500 in pension he or she isn't taxable. But, the dependant deduction you can claim is reduced by $1,000. There doesn't appear to be much sense in rolling any money into your spouse's RRSP if he or she isn't taxable. However, in this case it would increase your dependant deduction by $1,000. You save taxes at your rate rather than your spouse's.

The same theory applies to students. Even with a summer or part-time job they may not have earned enough to be taxable. However, they may be lost as a tax deduction. Once again, you

have tuition, RRSPs and other deductions that might end up saving you tax even though it doesn't help them.

Talking about RRSPs, while so many of us wait until the last minute to make our contributions, tax reform suggests we get in the habit of making them sooner. With the cancellation of the $1,000 investment-income deduction all interest is taxable. As a result, it's to our advantage to contribute monies to our plans now so the income will be earned tax free inside the plan rather than in our own names where it will be taxable. In addition, it's now important that next year's contribution be made in January rather than waiting 14 months until the final deadline.